GHOSTS OF VENTURA COUNTY'S HERITAGE VALLEY

EVIE YBARRA

Haunted America

Published by Haunted America
A Division of The History Press
Charleston, SC
www.historypress.net

Front cover: Newhall/Piru Mansion has been depicted as the haunted house on television programs such as *Charmed* and in various films. This Queen Anne–style home was built in 1890 by David C. Cook for his family. Later, it was owned by Hugh Warring and his family. Scott and Ruth Newhall purchased the mansion, and after the fire, they had the mansion completely restored. Today, it is privately owned as a wedding and event venue. It is Ventura County's Historical Landmark No. 4. *Photo by Robert Ybarra.*

Back cover, inset: Photograph of the east veranda of Camulos Ranch, as viewed from the north, 1901. *Public domain. Release under the CC by attribution license creativecommons.org/licenses/ by/3.0. Credit both University of Southern California Libraries and California Historical Society.*

First published 2016

Manufactured in the United States

ISBN 978.1.46711.985.6

Library of Congress Control Number: 2016930810

DEDICATION

My mother has been very influential throughout my life, and when I was a child, she told me my first ghost story. I dedicate this book to my mother, Minnie Ybarra, who always enjoyed sharing stories with my sister, Barbie; my brother, Robert; and me. She was known throughout our neighborhood as the greatest storyteller. Halloween was always special for us that way, and it was so much fun. She taught me the art of storytelling and the importance of technique and using one's own voice and style. She always kept us entranced with each of her stories, some of which were historical, while others were folklore and legends. It was always a great experience to gather around and listen to Mom's stories. I also dedicate this to my aunt Clara Gonzales, who used to keep me tirelessly entertained with her stories and still does to this day. She has also been a positive influence in our lives. This is also for the storyteller in all of us. Without stories, our past would be forgotten. Stories enrich our lives and are a form of historical preservation.

CONTENTS

Contents

FOREWORD

When people ask me if I grew up in Santa Paula, I tell them, "Not yet!" There's too much for me to learn and do here in the Santa Clara River Valley. I'm learning new things every day. I learn old things that are new to me. Evie Ybarra is one of my teachers and role models. She is digging deeper into the stories scattered throughout this valley than anyone I know. What a set of skills that requires! It takes a history detective to track down each story. Then it takes a researcher's skills to assemble all the details. Next, it takes a creative writer to reveal the stories behind the stories. In the end, it takes shamanic powers to connect the basic humanity revealed in all the stories with today's readers' collective humanity. By reading these tales, we all become more deeply connected with our own humanity by delving into the humanity of those who came before us. As we are entertained by Evie's stories, we become touched, moved and more deeply connected to the interdependent web of all existence of which we are a part.

The first book I wrote in 2002 was also from Arcadia Publishing. It was in the Images of America series. It was titled *St. Francis Dam Disaster*. I told the story of that flood using over two hundred photographs from my collection with extensive captions. I learned that out of every tragedy comes a certain amount of rebuilding and rebirth. I also curated several exhibits on the disaster for the California Oil Museum. I received a powerful piece of advice about exhibit design from Mike Nelson, who was the director of the museum at the time. He told me, "Tell the human story." Facts matter, but only if we use them to connect us to what it is that makes us human.

It does not make any difference if the stories that Evie collects and retells are fact or fiction, myth or reality. People throughout time have passed on all kinds of stories from one generation to the next, including myths, legends or facts from the newspapers of the time. All those stories deemed important enough to be passed on to future generations must contain the universal truth of what it is to be human.

That is the story that needs to constantly be retold, generation after generation.

—John Nichols, Author and Historian
JohnNicholsGallery.com

ACKNOWLEDGEMENTS

I want to thank all of the people in the communities of Santa Paula, Fillmore, Bardsdale and Piru who shared their stories with me for this book. I am grateful to those who were consultants for this project. A special thank-you to my son, Robert Jr., for his additional photographs and for driving me to all of those haunted locales. Thank you to my sister, Barbara Leija, for her encouragement and support, and to my brother, Robert Ybarra, for his assistance. I want to thank John Nichols for sharing his photo collection and stories. The photographs are one of a kind, and they tell the story of the Heritage Valley. I appreciate the assistance Craig Held provided as the research librarian for the Santa Paula Blanchard Community Library. Thank you to Mike and Kris Hyatt for all of their support and encouragement and to Ernie and Becky Morales for their support and for sharing their stories. Bob Cox, as always, has been very encouraging and extremely helpful and supportive. Thank you to Celeste Arnette, Pam Henderson Preciado, Missy Pennington Cervantez, Georgia Haase Beck, Linda Starnes Faris, Jeremy Leija, Eric Leija, Nancy Lehnhardt and Robert G. Sr. This project would not have been completed without everyone's encouragement and assistance. A special thank-you to Megan Laddusaw, Darcy Mahan and Hilary Parrish of The History Press for their assistance and excellent suggestions throughout this project.

INTRODUCTION

There are many stories and tales that are passed on from one generation to the next. There is no explanation about why these stories persist, but they become a part of our culture and our being. The ghost tales and stories about hauntings and the unexplained continue to fascinate. I wanted to chronicle some of these tales from the Heritage Valley, and I collected the most popular stories from the communities of Santa Paula, Fillmore and Piru. People were reticent at first because they did not want to be perceived as alarmists, but once they realized that there are others who have experienced similar sightings or have seen the unexplained, they shared their personal experiences.

Many of us grew up with the story of the "Lady in White by the Sycamore Tree" off Highway 126 between Santa Paula and Fillmore, California. Numerous people have reported seeing her, but then she disappears before their eyes. There is a story of buried treasure off Kenney Grove Park. Others claim to hear the cries of La Llorona—the crying woman—and see her along the Santa Clara River at night. The shadow people have been spotted in numerous places in the Heritage Valley, from private homes to inside schoolhouses.

The Billiwhack Dairy has been famously haunted in Aliso Canyon, and since the old "hotel" building was knocked down, not much activity has been reported there. The "hotel" was used as a barracks to house the workers in its early days, and when the building was abandoned, it seemed to serve as a magnet for those wanting to search for the Billiwhack

Monster. August Rubel built the dairy in 1924, only to have to close it down when his prized steer, Prince Aggie, died after ingesting some barbed wire. Rumors still abound about why this happened. Was it intentional? Why would he have ingested barbed wire? Then August Rubel moved his family to Rancho Camulos in Piru, where he built a schoolhouse for his children. August then disappeared in Tunisia during World War II, and the "official" story was that the ambulance he was driving hit a land mine. He had preserved Rancho Camulos in its original condition, and his widow carried on the same tradition even after she remarried. The family still owns the ranch to this day.

There are the numerous tales of unexplained occurrences in the old Sespe backcountry, as well as the legend of the "Lady of the Lake" from Lake Piru. The Mupu Indian legend of the "Lady of South Mountain" is very much alive in the Heritage Valley, and she can be seen on the western flank of South Mountain. Her profile is clearly visible from Foothill Road and Cummings Road in Santa Paula. These stories have been included in this book, and whether you believe in spirits, shadow people, ghosts and hauntings, these tales of folklore have defined the Santa Clarita Valley and have been passed on from generation to generation.

Santa Paula, California

THE LEGEND OF THE BILLIWHACK MONSTER

And as to being in a fright,
Allow me to remark
That Ghosts have just as good a right
In every way, to fear the light,
As Men to fear the dark.
—*Lewis Carroll,* Phantasmagoria

August Rubel was visiting a friend, John Fitzpatrick, in the Santa Paula Canyon in the early 1920s, and in 1922, he purchased the property known today as the Billiwhack Dairy and Ranch. August Rubel wanted to build the most beautiful dairy in the world, and he spent over $1 million to get it up and running. He also purchased the ranch's famous bull Prince Aggie from the Bard Ranch for over $100,000 at about the same time in 1922. Prince Aggie had toured all over the world and won prizes. When Rubel brought Prince Aggie home in early 1926—two days after the insurance policy on the animal had lapsed—Prince Aggie ingested something he shouldn't have. Allegedly, he was poisoned and died. The local veterinarian found barbed wire in his intestine.

Rubel also had purchased Rancho Camulos in 1924 at a good price because of the distressed condition it was in, and he decided to move his family to the historic Rancho Camulos in Piru while the dairy was still in operation in Santa Paula. The distance between the two ranches is 28.8 miles. August Rubel purchased the Billiwhack Ranch first in 1922,

and then he purchased Rancho Camulos in 1924. The dairy bottles had a print of Prince Aggie and a label that read, "Home of Prince Aggie, Ventura County." The Billiwhack Dairy was in operation for six months in 1926, but after Prince Aggie passed away, financial problems set in and Rubel closed the dairy. The family always suspected foul play in Prince Aggie's death.

The dairy was sold to a local businessman, Mr. Fracken, and he operated the dairy for ten years. The bottles from this era read, "Billiwhack Stock Farm." This incarnation of the dairy was in operation from 1932 to 1942.

Craig Held's grandfather purchased the Billiwhack Ranch in 1969, and he purchased the Billiwhack Dairy as a part of that property as well. In the 1950s, George Pezzold purchased the Billiwhack Dairy and Ranch, and he was planning to develop it into an amusement park, similar to Disneyland. George was a famous horseman, and he used to ride his horses in the Ventura County Fair Parade and the city parades. The former Billiwhack Dairy is a magnet for those looking for ghosts because they are lured by the folk tale of the Billiwhack Monster of Aliso Canyon.

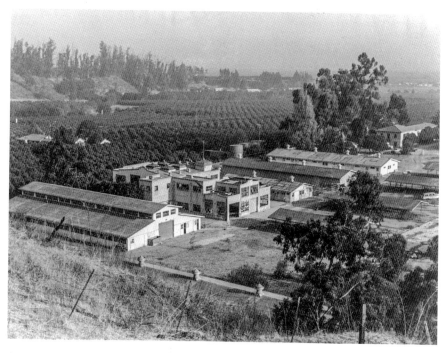

Aerial photograph of the Billiwhack Dairy. *John Nichols Gallery*

Billiwhack Ranch sign marking the private entrance to the ranch. *Robert G. Jr.*

The Billiwhack Monster has been described as a large, hairy, Bigfoot-type monster. Those who have seen him also claim he has claws and ram's horns on his head. The legend is that the dilapidated Billiwhack Dairy was once the site of a secret research facility and that August Rubel worked for the Office of Strategic Services (OSS), the precursor to the Central Intelligence Agency (CIA), and he was to bring in Nazi scientists to create "super soldiers." The Department of Defense used the property and its many underground rooms and underground tunnels. Something went awry in the creation, and the experimental soldiers had to be killed. The story goes that one escaped, but the other three were killed. Since the 1940s, people have claimed they have seen this creature and heard him growl. High school students went in search of this creature several times, only to be arrested because they were trespassing on private property. In 1967 alone, deputies took more than 270 trespassers into custody. As for August Rubel, he was killed in Tunisia during the war when the ambulance he was driving hit a land mine. Others claim he disappeared mysteriously in Tunisia.

The legend connects Rubel to the OSS, and if the legend is true, the OSS had Rubel performing experiments beneath the dairy. The OSS was started by William "Wild Bill" Donovan, who was made the coordinator of information in 1941. The OSS was handling the espionage and sabotage in Europe and Asia during World War II, and then it disbanded after the war. Donovan proposed that the organization continue, and it became the present-day CIA.

It has been reported that the Billiwhack Monster has thrown large rocks at cars, has pounded on the hoods of cars and has been seen carrying a large club. It was reported in a local newspaper in 1964 that the creature terrorized several hikers for a few hours until it let them go on their way.

Farmhands stayed in the large manor that overlooked the Rubel estate and Aliso Canyon. This building had underground parking, a large swimming pool and fountains. Everything was made of reinforced concrete, and the barns and milking sheds were tile-lined with full basements. The creamery was thoroughly refrigerated, and it had the best machinery of the day. The Billiwhack Dairy was later used for many things. In the 1950s, the defense department leased the creamery building, and the Department of Defense conducted research on the development of the infrared photography used in U-2 spy planes. In 1959, the county dog pound was housed there. In the 1960s, astronaut Scott Carpenter experimented with raising a wasp that killed harmful insects on the Billiwhack Ranch.

The first thing to go after the Held family purchased the Billiwhack Ranch and Dairy was the large hotel-like structure that looked like a haunted castle at night. It was a tall, two-story building that loomed over the landscape, and at night, its foreboding presence lured the curious onto the property. After the building was demolished, the number of trespassers dwindled dramatically. Now the buildings are leased out, and it is not used as a dairy. There are trees and it is in a remote area, so it appears spooky at night. Add to it the story of the Billiwhack Monster, and you have a recipe for the curious who pursue this urban legend.

Others claim to have seen and heard the unexplainable growl of an animal up Wheeler Canyon, which is close to Aliso Canyon. Is there such a cryptozoid creature in Ventura County? It's best to be safe and proceed with caution when driving up Aliso Canyon Road and Wheeler Canyon Road. One can't be sure when the Billiwhack Monster will make himself known.

The Department of Defense was conducting experiments related to teleportation in the late 1940s through the 1960s. The department was

very busy with the scientists and physicists as they developed the atom bomb. According to Project Pegasus, scientists Dr. Edward Teller and Dr. Oppenheimer worked with Tesla to develop teleportation. The idea of a super soldier was also part of the literary scene with the introduction of the comic book character of G.I. Joe, who first appeared in a comic strip in 1944. The point is that the concept of a "super soldier" was already on the minds of comic strip creators and toy makers.

There are tales of people hiking through the canyons and hearing strange growling sounds. Hikers have claimed to have seen a large, tall, furry creature peering at them through the brush and trees. Many of these hikers turn around and hike elsewhere. The setting is naturally beautiful, but even in the daylight, it lends itself to the imagination as the wind whistles through the trees and presents an eerie backdrop for finding a cryptozoid creature.

THE CURSE OF ALISO CANYON

Be wary then; best safety lies in fear.
—William Shakespeare, Hamlet

According to those who have been there, Aliso Canyon and Wheeler Canyon are cursed, and frightening or unexplained noises are often heard. Many tell about hiking or riding their horses up on the trails and hearing growling or loud, animalistic grunts. True, it *could* be a mountain lion with a sudden grunt or a coyote that growls like a bear, but it probably is not. Human beings have a sixth sense, and if they fear danger or sense an oncoming threat, they run. The survival instinct preserves human life.

One sunny day in June, several young women decided to take their horses up the riding trails in order to get some exercise and to connect with nature. Alexandra, Jane and Mary had become friends through their riding experiences. On this day in sunny California, the plan for the mother of two, Alexandra, was to drop off the kids at her mom's, and then she was to drive over to pick up Jane. They were to meet Mary at the stables since she lived only a few miles away.

The girls chatted about the legend of the Billiwhack Monster all the way to the stables. Alex claimed she knew some former high school classmates who had dared to venture in search of the monster. When they heard growls and unexplained noises, they were terrified and admitted that the monster did exist. They had heard it but not seen it. While they were chatting, Jane suddenly felt terror and fear that she could not explain. What if they heard

or saw this mysterious creature on their ride today? At least there were three of them, so they should be safe enough. The trails were out in the open hillsides and deemed safe for riders on horseback.

The girls met Mary in the stables, and after their horses were ready, off they went on the trail. Mary was first, second was Jane and Alexandra was third. Butterflies were flying around, and the sweet smell of honeysuckle permeated the air. One could detect the clean aroma of sage as well. Undoubtedly, the Native Americans who inhabited this area in days gone by must have enjoyed the mixtures of nature's aromas, including rosemary, sage and honeysuckle mixed with the pine trees. Mary went on ahead, and Jane and Alex were hanging back, enjoying the natural habitat as they gabbed about Jane's latest boyfriend. He was an airline pilot who was due to return from a trip tomorrow, so she was ecstatic.

Suddenly, they found themselves alone. They could not see Mary in the distance. Alex was getting thirsty, but Jane reminded her they would be going to lunch soon and should be heading back in a few minutes. Alex called out to Mary, and so did Jane, but they didn't get a response. Birds had been chirping earlier, but now there was dead silence.

Suddenly, Jane and Alex heard something rustling in the bushes near them. Whatever it was started to move, and it slowly separated some leaves and peeked out. Both saw the creature at the same time—it was something dark and hairy. It looked big and burly. It remained behind the bushes, staring back at the two girls with its huge, dark eyes.

Jane's horse lunged, leaped and stood up on its hind legs, throwing her off. Alex held on to her horse as it tried to run. Screaming for help by this time, Alex pulled out her cellphone, and luckily she did have a signal. She phoned 911. She summoned help, and the rescue helicopter was on its way. By this time, Mary had returned, and she assisted in making Jane comfortable until the medics whisked her away.

Mary and Alex were devastated after the accident. Jane lay in a coma for several weeks. When her body could not endure any more, she was laid to rest three months after the accident. Alex was left to explain what they saw that day and what had spooked Jane's horse. Alex described the growling and grunting as inhuman, and loud. A furry creature had been hiding behind the large bushes, and it didn't resemble any animal Alex was familiar with—not even a bear, because this particular creature appeared to have horns on top of its head.

A month after Jane passed away as a result of her accident, one of her friends, Michael, was watching a game on television when the doorbell rang.

Looking up the canyon. *Robert G. Jr.*

He went to answer the door, but no one was there. This occurred at about seven o'clock in the early evening in September. Michael had attended high school with Jane, and they knew each other well. He sat down to continue his game, and the doorbell rang again. Upon opening the door, he didn't see anyone, so he stepped outside and looked around for anyone hiding on the front patio. Again, no one was there. Michael's mom and dad were busy in the kitchen, and they heard the doorbell ring as well.

The sky was grayer than usual, and there was a slight chill in the air, but it was still daylight. Michael sat down to resume his game when the doorbell rang for the third time. Michael's mom went to open the door, and she didn't see anyone there either. As she surveyed the neighborhood, she noticed the neighbor's garage door swinging up and down on its own.

Upon witnessing the garage door's movement, she exclaimed, "What is going on here? This doesn't make sense. I wouldn't have believed this if someone would have told me the doorbell rang on its own, or that the neighbor's garage door is going crazy…hmmm." Michael's mom was bewildered. This never happened before. His dad also witnessed the neighbor's garage door going up and down.

"It must be just a fluke," he said. "Let's get inside." Michael's dad was calm as he gathered his family off the porch and told them to step inside the

Haunted area near the old riding trails in Aliso Canyon. *Robert G. Jr.*

house. They tried to concentrate on the television program, but they were obviously distracted when the doorbell rang again. Michael's dad jumped up and rushed to the door. When he opened it, there was an empty porch. The neighbor's garage door was still now. Michael's dad disconnected the doorbell. They had enough doorbell ringing for one day. When they stepped out on the porch to see if anyone else's garage door was going up and down, Michael picked up a pewter necklace that was on top of the railing. It was strung on a piece of dark leather, and adjacent to the necklace was a four-inch silver turtle that was used as a candleholder. Michael's face went pale.

"These belonged to Jane," he said. "Someone must have brought them here, and maybe that's who was ringing the doorbell." They all exchanged glances for they knew no one had been found near the house or hiding somewhere nearby. Michael added, "No, I think Jane came back to let me know she is still with us." To this day, the doorbell remains disconnected, and Michael kept Jane's necklace and turtle candle holder. Those were two items he had given her for her birthday five years earlier.

THE HAUNTED BUS STOP

The lawn
Is pressed by unseen feet, and ghosts return
Gently at twilight, gently go at dawn,
The sad intangible who grieve and yearn…
—T.S. Eliot, "To Walter de la Mare"

Along Foothill Road and Wheeler Canyon Road, near the Limoneira Ranch, there was a bus stop where the children would wait for the school bus to take them to school, and it would drop them off there after school. One day, a child was hit by a car as he crossed the street. Tragically, he was declared dead at the scene. The narrow, two-lane road can be treacherous, and when there is a lot of traffic, it can get very crowded. Children are not accustomed to having to share the road with cars.

One night, Clara and Peter stopped along the roadway to admire the stars and the full moon. The young couple stepped out of the car and were leaning against the passenger side of the car, looking upward, when the silence was broken by a sound of snapping twigs. Someone was walking toward them. Peter looked in the direction of the sounds and saw a child walking along the road, but the child seemed oblivious to the young couple ahead of him. Clara also saw the boy. The child was swinging his lunch box, and he was wearing a shirt, jeans and tennis shoes. Clara called out to him as he walked past them, but the child didn't seem to hear them as he disappeared into the darkness.

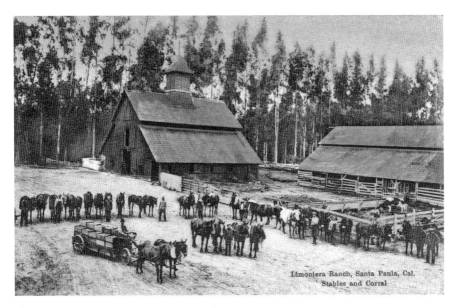

Vintage postcard of the Limoneira Ranch, near the haunted bus stop. *John Nichols Gallery.*

"No child should be walking out here all alone at night!" exclaimed Clara. Peter agreed with her, and they decided to find the boy and offer him a ride home. They got into the car and drove toward the city of Santa Paula. Straight ahead, they saw a figure of a child alongside the roadway. Peter pulled up next to him and stopped the car. Clara rolled down the window and asked him, "Would you like us to take you home? It's too dangerous out here alone at night." The boy turned around to look at her—and then he was gone! He disappeared into thin air right in front of them.

Clara was suddenly terrified. Peter had seen him as well, and they had no explanation for the child's disappearance before their very eyes. Clara was so freaked out that she kept the lights on inside of the car as they drove home in the darkness. The next morning, they both went to church and told their parents about what they had seen. No one had a good explanation.

Years later, Clara attended a community fundraiser with her husband, Bill, and one of the guests started talking about the haunted bus stop. The guest was a longtime resident of Santa Paula, and she told the group about her experience there. The lady, Connie, explained that she took her sister to the haunted bus stop near Wheeler Canyon Road and Foothill Road. Connie said she had stopped the car in the darkness—all headlights and interior car lights

Right: Wheeler Canyon Road sign near the haunted bus stop. *Robert G. Jr.*

Below: Scene of the haunted bus stop. *Robert G. Jr.*

were off when suddenly they saw a child standing outside the car, just staring at them. Connie and her sister wondered if this was the ghost child everyone had talked about. They were scared, so they decided to leave, and as soon as the car started, the ghostly boy disappeared. Connie was visibly shaken as she recounted the story, and Clara chimed in that she, too, had seen the ghost of the little boy; the other guests gasped in surprise and in fear.

Was there such a thing as the haunted bus stop in the outskirts of the city? The local residents of the community do not want to see this ghost, as they are fearful of the unknown, yet this ghostly legend persists because others have since claimed to have witnessed this ghost boy walking along Foothill Road after midnight. They really didn't expect to see him, but they did. Be careful what you wish for!

The Legend of the Lady of South Mountain and Haunted Steckel Park

O Death, rock me asleep,
Bring me to quiet rest,
Let pass my weary guiltless ghost
Out of my careful breast.
—Anne Boleyn

When you drive eastward on Foothill Road toward Santa Paula and look southward across the valley toward South Mountain, you can clearly see the profile of a lady on the eastern flank of South Mountain. She is known as the Mupu Indian Maiden, the Lady of South Mountain. The Chumash settlement near today's Santa Paula was called Mupu, and the tribe there had a forewarning of their destruction by a tidal wave. To forestall that, the daughter of the chief was sacrificed at the coast, along the Pacific Ocean. When the tribe members were returning to Mupu after the sacrifice, they saw the maiden immortalized in the shape of South Mountain. The shape they saw was the profile of her face, neck and breasts as if she were reclining, facing the Mupu area.

This story has been circulated throughout the community of Santa Paula and Ojai for many years. The story was also printed on the menus used at the original Mupu Bar and Grill on Main Street in Santa Paula. There has been a pageant enacted in Santa Paula in tribute to the Lady of South

Silhouette of the Lady of South Mountain. *Robert G. Jr.*

Mountain from the 1940s to the present time. Marie Weiler played the role of the Mupu Indian Maiden, and she also sang when the pageant of the Lady of South Mountain was produced in 1940 in Santa Paula. Steve McQueen and his third wife, Barbara, lived on a ranch on South Mountain for the last eighteen months of his life. He liked the privacy he had there, where he could raise his horses and avocados and fly his biplanes.

In the remote area of Santa Paula, where the Mupu settlement thrived, there are tales of sightings of beautiful birds and unusual sounds in the wilderness. Resident historian John Nichols has devoted an entire chapter to the Lady of South Mountain in his new book *Essay Man: Selected Essays and Writings*, published as a Kindle book in 2015.

"As the legend was told in ancient times Winona was taken up South Mountain amid much wailing and sorrow," wrote Nichols. "There were chants and solemn dances as she was laid out on the earth where she expired. Her sacrifice saved the valley. The grass grew, the birds sang again and the valley was alive." Her father, Chief Red Fox, allowed the voice of the Great Spirit to tell him that his daughter had to be sacrificed to save the people. As

Nichols explained, "Every evening near sunset you can look over at South Mountain and see the profile of Winona."

This Mupu settlement is located in the area adjacent to what is now Steckel Park.

HAUNTED STECKEL PARK

Do I believe in ghosts? No, but I'm afraid of them.
—Marquise du Deffand

Steckel Park is located off Highway 150, which is one of the main thoroughfares to Ojai, California. The bird aviary is charming because there are peacocks and many other birds you can view and photograph up close. Many unusual stories originate in Steckel Park, and this area used to be inhabited by the Mupu Native Americans. After dark, you may bump into a shadow person or hear voices speaking in a language with which you are not familiar.

There is a story of a former park intern who used to live in the house on the Steckel Park grounds, and a ghost of a child and an elderly man appeared at two different times at the house. After six months, the internship was completed, and this ranger moved. While camping at Steckel Park, people often claim that they get the feeling of being watched, and unusual animal sounds can be heard.

One night, one such group of campers was staying in the park overnight, and after they ate their dinner of fried fish and potatoes, they decided to sit around the campfire and tell ghost stories. Everyone was listening to the

A peacock wandering freely along the Steckel Park aviary. *Robert G. Jr.*

Former park ranger intern's living quarters. *Robert G. Jr.*

storyteller when suddenly they heard the sounds of twigs breaking and leaves rustling, as though someone was approaching their camp. After a quick head count, all six people were accounted for—no one in their group was on the walking trail. What kind of animal could be out there lurking at this time of night? Growling sounds came from the bushes and strange animal-like grunts as well. One of the men, Sammy, decided to try to see what it was that was attempting to enter their camp. He had his large flashlight with him and a baseball bat. The others were too frightened to laugh, and they were hoping the creature would be a small, harmless raccoon or something similar. There was a bright light shining off in the distance; someone was on the trail with a powerful flashlight. It was coming in their direction. A feeling of sudden panic overtook two of the campers, who darted away and hid in the brush. The other four were left standing in the stranger's path. The group waited while the light approached, growing brighter and larger. There was a bump in the trail ahead, so the light wasn't totally visible—and then it was gone.

The other two ran out of the bushes and yelled, "Look behind you! There's a round light up above us. It's a ball of light." The others turned around, and they all saw it circling around them and watching them. It was just a circle of

light. "It's an orb, that has to be an orb," Sammy exclaimed in surprise. The group stood transfixed and decided it was just too much for them; they would not sleep that night. They thought they could take turns keeping watch while the others slept, but growling sounds could be heard coming from the brush nearby. This wasn't going to work. They packed up everything as quickly as they could and took off. They couldn't explain the circle of light that they witnessed dancing around them, nor could they attribute the growling sounds to any particular wild animal. It sounded human.

THE HAUNTED GLEN TAVERN INN

While yet a boy I sought for ghosts, and sped
Through many a listening chamber, cave and ruin,
And starlight wood, with fearful steps pursuing
Hopes of high talk with the departed dead.
—*Percy Bysshe Shelley, "Hymn to Intellectual Beauty"*

The Glen Tavern Inn is well known throughout the country and across the sea as a fine hotel, and its restaurant serves new-world cuisine. It is also famous for its ghosts and spirit apparitions, which frequent the lobby, the staircase and various rooms, according to many people who have resided there or visited the inn. Several staff members discussed how things were moved and found out of place from where they had been put down. One man put his hat on a chair in the lobby, only to return to find it on top of the fireplace mantel. One restaurant manager locked up and closed the kitchen for the night, and when she returned the next morning, the silverware was out of place and scattered everywhere in the dining room. A receptionist was sitting in the lobby of the Glen Tavern Inn reading a book during his short break when suddenly, on the table next to him, the lamp moved on its own and fell into his lap across his legs. Nobody was there to lift it and push it onto his lap, and nobody was even close to where he was sitting. He let out a cry of surprise, and he put the lamp back on the table.

John, the hotel concierge, explains, "Things like that happen all the time here. Many visitors have heard a child riding a tricycle through the second-

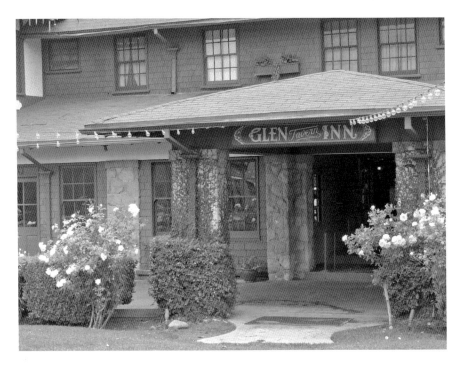

The entrance to the Glen Tavern Inn in Santa Paula, California. *Robert G. Jr.*

floor hallway laughing." Several staff members claimed to have seen an elderly man sitting next to the fireplace in the main lobby, only to disappear within moments. One of the guests, Mr. Harvey Van Norman, resided at the Glen Tavern Inn in 1928, just after the St. Francis Dam collapsed, so he could assist with the rebuilding efforts. After dinner, Van Norman used to drink his coffee next to the fireplace in the main lobby, where he would visit with some of the guests visiting the Glen Tavern Inn.

Specters and apparitions are commonplace here. Items are moved out of place, especially at night. One hotel guest explained that one night he had been asleep when something awakened him. Maybe it was a noise or something of that nature, but when he sat up in bed, the door to the bathroom facing him opened on its own. There weren't any windows open for a breeze to push it open, and the doors are solid wood and not easy to open on their own. He turned on the light, and nothing was there. He was totally alone in his room—but there was a spirit ghost in there with him. He was in a room on the second floor.

If you want to be certain to see one of the resident spirits or an apparition, check into room 307. The legend is that a prostitute was murdered in the

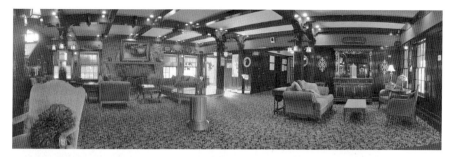

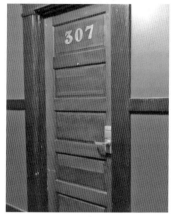

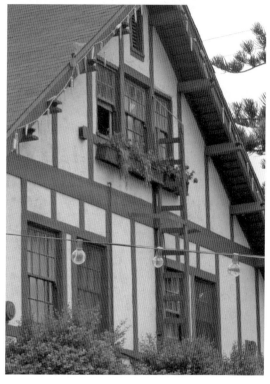

Top: Lobby of the Glen Tavern Inn, where apparitions have been seen. *Robert G. Jr.*

Above: Guests claim room 307 at the Glen Tavern Inn is a haunted room. *Robert G. Jr.*

Right: An outdoor view of room 307 from the front entrance. *Robert G. Jr.*

closet in this room. You may hear strange sounds and smell perfume, or you may be visited by the lady who was murdered in this room.

The Glen Tavern Inn was built in 1911. The Tudor-Craftsman hotel was built by famed architects Burns and Hunt, and it was situated opposite the train depot in order to provide accommodations to the many travelers visiting the area. During Prohibition, the inn was used as a speakeasy, brothel and gambling parlor. Of the many legends of the Glen Tavern Inn, one is that of a child who drowned in a second-floor bathtub. He was two years old at the time of his death.

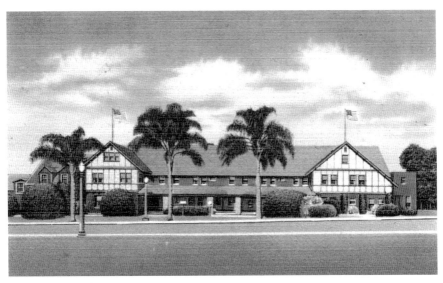

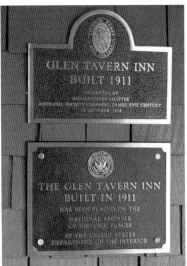

Above: A postcard view of the Glen Tavern Inn in Santa Paula, California. *Public domain.*

Left: These are the plaques commemorating the historical landmark status of the Glen Tavern Inn. *Robert G. Jr.*

In the 1930s, the Glen Tavern Inn hosted various Hollywood notables, including Carol Lombard, John Wayne, Houdini and the famous canine Rin Tin Tin.

On July 26, 1984, the Glen Tavern Inn was added to the National Register of Historic Places. It is also an official City of Santa Paula Landmark and Ventura County Landmark.

PHANTOM CHILD OF THE GLEN TAVERN INN

When I'm asked, "Are you afraid of the dark?," my answer is, "No, I'm afraid of what is in the dark."
—Barry Fitzgerald

The young boy, Pablo, shared his story with the class when we were discussing opening paragraphs for creative writing. He raised his hand, and after being called on, he stood up. Without stammering or showing any sign of stage fright, he proceeded.

We used to live in the Glen Tavern Inn because my parents both worked there for many years. We lived in two rooms on the second floor of the hotel. One night, we were all together watching television, and we heard running down the hall and the bouncing of a ball. My mom peeked out and looked down the hall, and she said there was a little boy playing at the other end and bouncing a large, red ball. We didn't know who would be playing because it was after 8:00 p.m., and all guests are supposed to watch over their children. This child was alone. It was quiet for a few minutes, so we assumed his mom came to get him. Then we heard steps running down the hall in the other direction, and we heard the distinct sound of a bouncing ball on the carpet. This time, my mom stepped out into the hallway, and she went looking for the little boy. She returned and explained that she couldn't find him, so he must have gone back into his family's room. Within five minutes, we heard running again. My dad stepped outside and walked down the hallway. He returned, telling us the little boy had ignored him and kept on playing and ran down the stairs. He asked my mom to call the front desk to explain that a child was alone playing in the hotel. Mom picked up the telephone and made the call.

"Yes, he is about four years old and he is alone running around and bouncing a red ball," she said. Then she went white as a sheet. The blood drained from her face as she put down the telephone.

"They said no one else is in the hotel tonight," my mom reported. "We are alone, and there is no child registered with a family. The desk clerk explained that people have seen a small boy playing in the hotel's second-floor hallway, only to disappear in midair. He is allegedly the child who drowned in one of the second-floor bathtubs while his family was staying here years ago."

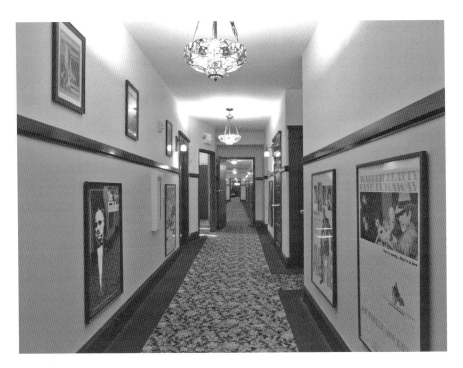

The second-floor hallway of the Glen Tavern Inn. *Robert G. Jr.*

The class was entranced with the story. Pablo was unnerved and very serious as he continued his tale:

> *We all heard the sounds, my mom and dad both saw this boy, and then to be told he wasn't "real" was certainly a shock to us. Later that night, we were in bed, and my brother and I were in the adjoining room to our parents when we realized we couldn't sleep because we were thinking about the boy. Then he came back! My brother, Juan, and I, both sat straight up in bed when we heard light footsteps running down the hall with the bouncing ball. We jumped out of bed and opened our door. I peeked out, and I could see a child playing with a red ball at the other end of the hall. My brother was standing behind me, and as we crept forward, we both saw this child. He was wearing blue shorts, a white shirt and small brown shoes and socks. He had short, brown hair, and he looked happy as he was playing and laughing with his ball. My parents woke up from the sounds of laughter coming from this child. My mom stepped out of her room and walked toward the child, and we followed her.*

"Little boy," she called. "Where are your parents? Do you want me to take you back to your room?"

The child looked at her, and he disappeared right before our eyes! Just like that, he was there, and then he was gone! We were stunned! The room suddenly changed temperature and we were so cold.

Hector stood up and proceeded to share his experience at the Glen Tavern Inn:

When my dad worked there, my family and I went to have dinner there one night, and after we ate, we gathered in the lobby by the warm fireplace. A crowd had gathered, and one of the staff members told this story about what had happened to him that morning. He said he was cleaning the kitchen and sorting the vegetables and fruits for the evening meals, when suddenly a plate went flying off the shelf and crashed to the floor on its own. No one else was in the kitchen. When he thought it was just a freak occurrence, the box of oranges turned itself over and all the oranges fell

Looking down the staircase from the third-floor lobby of the Glen Tavern Inn. *Robert G. Jr.*

to the floor. It was then that his skin began to crawl, and he knew the definition of fear. He walked out of the kitchen only to return with two other staff members to help him complete his tasks. That is what he told us that day and I shall never forget that story.

Hector continued, "My dad saw some amazing things too. He told us how once he got locked inside the bathroom because the lock wouldn't open, and he stated very emphatically, 'Stuff like that happens all the time here at the Inn.'"

ISBELL SCHOOL

SHADOW PEOPLE

Where there is no imagination, there is no horror.
—*Sir Arthur Conan Doyle*

A shadow person can also be known as a shadow figure or a shadow being. It is perceived as a shadow of a living, human figure by the believers of the supernatural or paranormal. They claim it is a presence of spirit or other entity.

The Isbell School was named after the first American female teacher in California, Olive Mann Isbell. She had taught in Santa Clara, and she returned to Santa Paula to live. Isbell School was the site of significant flooding during the St. Francis Dam disaster, which occurred three minutes before midnight on the night of March 12, 1928. The major devastation began in the early hours on March 13 as the waters traveled down San Francisquito Canyon, wiping out Powerhouse 1 and Powerhouse 2, before they rumbled through Castaic and the Edison Camp.

Jon Wilkman describes the scene in his book, *Floodpath: The Deadliest Man-Made Disaster of 20ᵗʰ-Century America and the Making of Modern Los Angeles*:

> *As the deluge rolled toward the Pacific Ocean, it was two miles wide, it slowed to seven miles per hour but retained plenty of destructive power. In Santa Paula, most of the damage, and all of the dead, were below main*

street, but fourteen homes floated lazily around the two-story Isbell School, a block from downtown…Around 5:25 A.M. on March 13, nearly five and a half hours after the collapse of the St. Francis Dam…12.4 billion gallons of water slipped into the surf between Oxnard and Ventura…and into the Pacific Ocean.

The entire first floor of Isbell School was flooded with mud, debris and broken glass. Isbell School was built in 1926, and it is located at 221 South Fourth Street in Santa Paula, California, and is Ventura County Historical Landmark No. 143.

One afternoon, three teachers stayed late to work on a school project, and another had extra papers to correct, so they gathered in Sylvia's classroom to work together. After 5:00 p.m., the custodian walked in and reminded them not to stay too late because it would get dark within an hour. The one teacher who was correcting papers decided to leave, but the other three continued working for a bit longer before deciding it was time to quit and go home to their families. Sylvia collected her papers and placed them into her "teacher box" to take home. The other two teachers left to go back to their classrooms to lock up and make their way home. Sylvia went to her desk to pick up her purse, sweater and the large teacher box. She stepped out of her classroom, locked the door from the outside and walked toward the elevator in the middle of the building. Her hands were full; she was carrying the teacher box with both hands, and her purse and sweater were sitting on top of the large plastic tub. As she went down the hallway toward

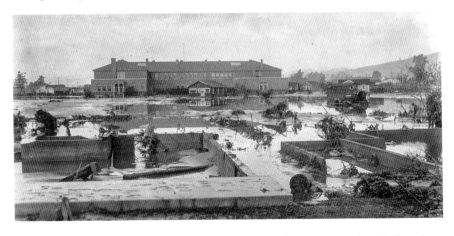

Isbell School after the St. Francis Dam disaster. Over two thousand cubic feet of silt and debris had to be cleaned out of the entire first floor. *John Nichols Gallery.*

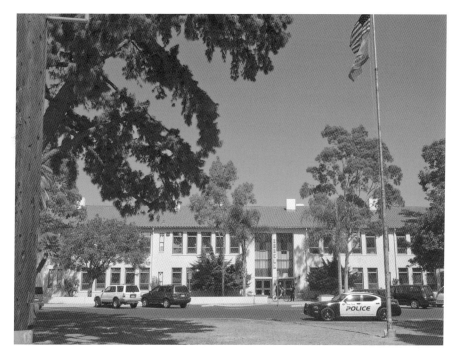

Isbell Middle School today, at 221 Fourth Street in Santa Paula. *Robert G. Jr.*

the elevator, she realized she needed to put the box down in order to push the down button. Suddenly, the elevator doors opened on their own. To her surprise, the elevator was empty as she entered, carrying the large tub with her purse and sweater on top. She didn't think too much about it because she just wanted to get home.

A week later, the same thing happened again when she attempted to leave. It was already after 5:00 p.m., and she had her hands full with her teacher box, purse, sweater and some student notebooks she needed to correct that night. She found herself approaching the elevator, and as she was about to put her tub on the floor, the elevator doors flew open. Without bothering to wonder what happened, she jumped in and the doors closed on their own.

Down it went to the first floor. When she stepped out into the first-floor foyer, she saw a person walking down to the main office. It was the figure of a man in a suit and a hat. Sylvia didn't stop to ask questions as she made her way toward her car. In the parking lot were the custodian's truck and her silver car. The principal had already left; his parking space was empty.

She loaded up her car, and as she was about to fasten her seat belt, she glanced at the front façade of the school. She saw another man with a hat walking out of the shadows toward the cluster of trees next to the parking lot. He walked behind the trees, and she waited for him to emerge, but she didn't see him. Was he standing behind the large pine tree? Why? She decided she needed to look for him. She moved her car toward the trees and drove around them, but there wasn't anyone there. He had just disappeared.

Others reported seeing shadows of people around the area, only to watch them disappear without a trace. Some of the neighbors talked about seeing people walk down the sidewalk, and after they walked behind trees or bushes, they never emerged.

Was it one of those shadow people Sylvia witnessed walking behind the pine tree? Had it also been a shadow person pushing the elevator buttons because he saw she needed help?

THE POLTERGEIST IN THE SCHOOL LIBRARY

At night, here in the library, the ghosts have voices.
—*Alberto Manguel,* The Library at Night

The librarian told the story to the class about the day the book was thrown off the shelf. It happened when she was sorting through and checking in some books for the day. Margarite, the librarian from a neighboring school, was visiting Cynthia and helping to sort out the old books to replace them with the new books they had just recorded earlier in the day. Suddenly, a book came off the shelf. No one else was present in the small library but the two librarians, and they were at the checkout desk in the middle of the room, away from the bookshelves.

"Did you see that?" Cynthia nervously asked Margarite.

"No, I didn't see it, but I heard it!" Margarite was looking around for the book she had heard hit the bookcase across the way. She spotted it on the floor adjacent to the checkout desk.

"There's the book, Cynthia—it's a copy of a Nancy Drew mystery, *The Ghost of Blackwood Hall.*"

They continued working and tried not to think of the incident. But as the two were putting things away and closing up for the day, they saw it as plain as day—this time, two books flew off the shelf. It looked as though someone

took the books and threw them across the room, but no one was there to do that. Both women witnessed this event.

A few weeks later, the last class of the day was preparing to leave the library after the students had each checked out a book. They were lined up by the door, and as their teacher was preparing to dismiss them, suddenly there was a commotion by the bookshelf in the center of the room. Then a girl in line cried out, "Look, all the books came out of the bottom shelf! They are all on the floor!"

The students, the teacher and the librarian were stunned. At least ten books were knocked out and removed from the bottom shelf of the library, and they lay scattered on the floor. Cynthia told the students the story of when the books came flying off the shelf when she and Margarite had been sorting books a few weeks earlier. The librarian explained that this occurrence was unusual and that she thought it was the spirit of a child or a former librarian in the school.

The students remembered that Isbell School had mud and debris throughout the first floor of Isbell School after the St. Francis Dam failed in

Isbell School after the St. Francis Dam disaster of March 13, 1928. *John Nichols Gallery.*

1928. "Maybe it's one of those people who is here," one student commented. "They must have loved this school because they never left."

Because silt and debris covered the entire first floor of Isbell School after the dam disaster, the cleanup efforts were overwhelming. Over two thousand cubic feet of silt was removed from the bottom floor, and volunteers assisted in these efforts, so perhaps among some of these volunteers were young people. One cubic foot of this material weighs 120 pounds, and if you have two thousand cubic feet, that's about 245,000 pounds of weight.

The dam breaking was a tragedy, and so many lives were lost. Bodies washed down the river or were caught in trees, and many of the dead were recovered from tree branches or from collapsed buildings. Others were wedged between rocks and debris. Other bodies of loved ones were never recovered.

Poltergeist activity is the term for a "noisy ghost" or other supernatural being supposedly responsible for physical disturbances, loud noises or objects being moved or destroyed. Poltergeists knock on doors or move objects, and they have been known to trip people. "Poltergeist" comes from the German words *poltern*, which means to make a sound or a rumble, and *geist*, which means ghost. According to paranormal researchers, a poltergeist is usually a young preteen and usually a girl. This particular poltergeist at the library sounded as though she (or he) was playful and simply seeking attention.

STRANGE LIGHTS IN THE ATTIC

Whenever I take up a newspaper, I seem to see Ghosts gliding between the lines. Must be Ghosts all the country over, as thick as the sand of the sea…We are, one and all, so pitifully afraid of the light.
—*Henrik Ibsen*, Ghosts

Neighbors who live near the Isbell School have reported seeing lights in the upstairs room in the center of the second floor of the main building. Sometimes the lights come on after midnight and other times after two o'clock in the morning. Nobody is working at the school at that hour. The lights turn on, and then five minutes later, they are turned off. Several people reported what they witnessed to school authorities, but nothing ever explained what could have caused the lights to turn on and off by themselves. Now it has become commonplace for the lights to turn on by themselves.

The glass windows of the workroom where lights have been seen after midnight. *Robert G. Jr.*

The local legend is that victims of the St. Francis Dam disaster have returned and are looking for their loved ones. Others claim that they have heard strange sounds inside the main building at night. Some of the custodians have experienced strange things after hours. They hear footsteps coming down the hall when there is no one else in the building. The elevator doors open and close on their own, but no one is present to push the elevator buttons in the first place.

One night, one of the custodians who was cleaning during the night shift felt as though he was being watched. He looked up from sweeping and saw someone pass by the open classroom door and proceed down the hall. He went out to see who it was, but when he reached the open doorway and stepped out in the hall, no one was there. He called out, "Hello, who is out there?" No response. Thinking maybe he was just seeing things, he went back to his sweeping. He decided he was finished in this classroom and closed up and went to the classroom next door. As he was opening the door, he heard the elevator doors open. He rushed down the hallway toward the elevator, and there was the elevator, with its doors open, but

no one was inside. Feeling uncomfortable, he rushed back and emptied the trash of the last classroom and took off for the night. He was hesitant to take the elevator down to the second floor, so instead he took the stairs. He made sure everything was locked and all the interior lights were turned off. As he walked out to his car, he noticed a glow of light on the sidewalk. He looked up to the source of the light and saw that the lights were on in the second-floor staff workroom. He knew he had turned off all the lights, and he rushed to his car so he could go home.

Suddenly, appearing from nowhere, he saw a dark shadow of a man walking away from the building. Was this the man who had been inside? Did this man push the elevator buttons? The custodian turned on his flashlight and shone it toward the man, saying, "Hello! Were you inside the building just now?" But the light only illuminated the wall, and there was nothing there—no man. The light was shining and illuminating the building. The shadow man was nowhere to be seen.

THE CLASSROOM

One need not be a chamber to be haunted.
—Emily Dickinson

One morning, there was a fire drill at the school, and the entire campus had to be evacuated. While the students were outside with their teachers, they were waiting for the all-clear signal in order to return to their classrooms. In the office, the staff was ready to ring the all-clear bell when one of the secretaries heard noises coming through the intercom of one of the classrooms. There were sounds of furniture being dragged across the floor: desks were being moved, and chairs were heard screeching across the wood floor. The office manager called into the classroom and told whoever was inside to please go outside for the fire drill. No one answered, but the sounds of furniture being dragged across the floor continued. The office manager and another secretary walked down the hall to that classroom. To their surprise, the door was locked. The office manger had a master key, so she unlocked the classroom door. Both women entered the classroom. The lights were turned off, furniture was scattered all over the classroom and desks, chairs and books were strewn across the floor in disarray. The teacher's desk was cleared off, and all of his papers were on the floor. They radioed for assistance, and the

custodian and school principal arrived. They searched the room, but no one was found to be hiding in any part of the classroom. The all-clear bell sounded, and as students were returning to their classrooms, the students from this particular classroom were asked to wait outside the door.

The principal explained the situation, and he asked the students to help straighten out the classroom and to rearrange the desks and chairs. Upon seeing the classroom, the students were surprised that someone could have done this. It was unbelievable for a person to cause such a mess in such a short time. They were outside for no longer than fifteen minutes. It took these students over twenty minutes to rearrange the desks and chairs and another ten minutes to pick up all the books and papers. On one of the desks, there were muddy handprints. You could see the large prints, and they left a heavy coat of mud. On another desk, there were pieces of long weeds caked in mud.

The teacher and students couldn't understand who would have left muddied handprints in the classroom. Who did they belong to? Why did this person move all the furniture and create havoc in this classroom?

The school was abuzz with the news about what had happened, and since there was no logical explanation, the stories were numerous. During a discussion in one of the history classes, several students remembered reading about the St. Francis Dam disaster of 1928. After the disaster, there had been mud and debris throughout the first floor of the school. Dead bodies were swept into the school by the water as well. The students' theory was that someone from the past—maybe more than one person—had returned to the school and that they were caught in a time warp.

A poltergeist or several of them may have been in the classroom creating havoc, or maybe it was an inside "prank" by one of the staff members to keep the tales alive about the poltergeist in the school. If everyone was outside for a fire drill, then who was it?

SANTA PAULA CEMETERY

'Tis now the very witching time of night,
When churchyards yawn and
Hell itself breathes out
Contagion to this world.
—*William Shakespeare,* Hamlet

The Santa Paula Cemetery was incorporated in 1903, and it is actually a combination of three cemeteries. Today, it is known as the Pierce Brothers Santa Paula Cemetery. Many active ghost sightings occur at cemeteries. After the Saint Francis Dam disaster, Santa Paula's community was devastated by the floodwaters. The Santa Paula Depot was used as a makeshift morgue, and there were numerous unidentified bodies stacked up until the morticians could have them cleaned and identified. Coroner Oliver Reardon was attempting to determine the exact cause of death for all the victims.

Not only did residents lose many loved ones, but property was also destroyed. The community had to come together to rebuild and to recover from its grief. At the Santa Paula Cemetery, fifty-eight were buried as a result of the disaster.

The local lore attributes the sightings of apparitions to restless spirits and to those who died violent and instant deaths. One Halloween night, some high school boys decided to test their bravery by walking through the cemetery at night. This was typical behavior on the part of some, but for

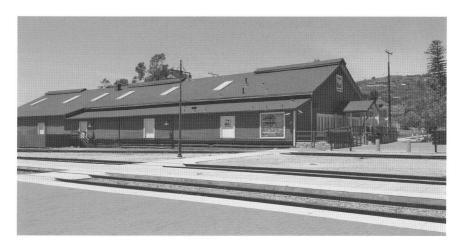

The Santa Paula Train Depot was used as a temporary morgue following the collapse of the St. Francis Dam. *Robert Ybarra.*

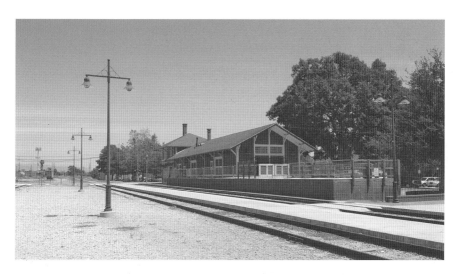

Another view of the Santa Paula Train Depot, which is located across the street from the Glen Tavern Inn. Today it is part of the Agriculture Museum complex of the Museum of Ventura County in Santa Paula and Ventura. *Robert Ybarra.*

others, they had never set foot in a cemetery at night. The group of friends had attended a Halloween party at Melissa's house on the outskirts of Santa Paula. The party was attended by over fifty teenage kids. There were also ten sets of parents on hand to help chaperone this celebration.

Parents try to keep their children safe and out of harm's way, so they all thought keeping them occupied at a friends' party would be the best

solution. Little did they know that these four had already devised a plan to walk through the cemetery about midnight. They knew there would be four of them, so that gave them a sense of false bravery and courage.

Everyone was enjoying themselves, bobbing for apples, snacking and dancing, and they decided to share ghost stories. One of the girls told the group about the spirit of the woman in the cemetery who was known to chase people around the tombstones. Another shared that her uncle used to work at the cemetery—and she shared what had made him quit his job. He had helped dig a deep grave site for a casket, and after the funeral service, he was helping to bury the casket in the ground. It was time for a break, so he went to get a cup of coffee and catch up on the day's events with the other workers. They returned to finish their burial, but when they returned, something was amiss. The casket was no longer flat on the ground, but at an angle. Some of the flower sprays were out of place, and there were red roses scattered around the grave site in a circle. This was too creepy. They had only been gone for fifteen minutes; nothing like this had ever happened before.

They called their boss, and he arrived on the scene. He surveyed the area and asked the men to see if the casket itself had been disturbed. Carlos was the brave one, and he jumped down into the hole and checked the casket.

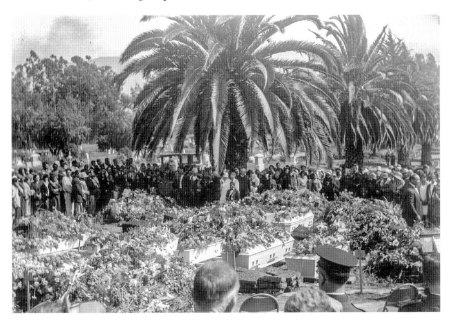

The city of Santa Paula mourns those lost in the St. Francis Dam collapse. The funeral procession walked through town all the way to the cemetery, where the funeral was held in March 1928. *John Nichols Gallery.*

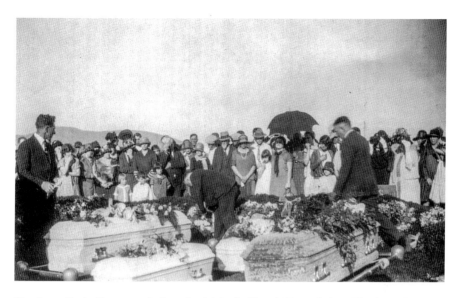

The Santa Paula Cemetery during a burial for St. Francis Dam victims. The Santa Paula Ebell Club collected flowers and wreaths from the community for all of the burials and grave sites to assist the families. *John Nichols Gallery.*

He saw that the top was loose, and not thinking it was a serious situation, he opened the lid. The blood drained from his face, and his expression said it all. He slammed the lid down and jumped on the back end of the casket so he could jump out of the newly dug grave.

"There's no one in there!" he shouted. The man who was dead and inside that casket is gone!"

The others were shocked, and his boss exclaimed, "OK, I believe you, but I have to see for myself." His boss jumped down and lifted the lid himself. He couldn't get out of there fast enough. He told everyone to stay because he had to try to track down the body.

After making a few calls to the mortuary, he called the police, and the family was informed. Someone had to have taken the body—these things don't walk out on their own. The police treated the area as a crime scene, and word spread quickly that there was a body snatcher on the loose in Santa Paula.

"My uncle could not sleep for days because he was so traumatized," the girl related. "He finally had to quit his job and he went to work in construction. He felt better building houses for the living."

SHADOWS IN THE PARK

Shadows of a thousand years rise again unseen,
Voices whisper in the trees, "Tonight is Halloween!"
—*Dexter Kozen*

O bregon Park sits in the middle of several clusters of homes on the west end of Santa Paula. It is a scenic area with manicured lawns and trees. It is ideal for taking the children to play basketball or to have a picnic. Many dog owners walk their dogs in the park, and the park benches are frequented by many of the owners, who sit and compare notes about their dogs.

A young female was murdered in the park late one night, and her body was discovered the next morning by a man walking his dog. The community was uneasy following this murder. Parents would not allow their children to go to the park alone, and pet owners only went in groups to walk their dogs. The young woman had met a violent death. After several months, a man was arrested for the alleged murder.

It was six months after her murder that mysterious sightings of shadow people and colored lights began to occur at the park. Two ladies were taking a walk through the park one late afternoon, and they sat down on one of the park benches to just sit and chat. They were oblivious to the fact that dusk had settled in and sunset had descended on the community. They lived nearby, so they weren't concerned about the impending darkness. They were deep in conversation about their families and comparing notes about their elderly parents, so they didn't notice the man on the other side of the park

Above: A view of Obregon Park in Santa Paula, California. *Robert G. Jr.*

Right: A shadow man has been seen near the Obregon Park sign. *Robert G. Jr.*

watching them. Helen was the first to leave, and she told Susie that she would see her the following day about 4:00 p.m. at the park. Susie remained sitting on the bench after she bid her friend goodbye. That's when she noticed him—the man across the way, leaning against a tree. He was dressed in dark clothing, and he was watching her.

Susie felt uneasy. She didn't know this man, and she had never seen him before. She picked up her small backpack from the bench and was carrying it with her. She avoided walking in front of the man, so she took the sidewalk trail to the other side of the park—the one closest to the nearby homes. She felt a sigh of relief because she thought she had slipped away quickly. As she headed home, from the corner of her eyes, she thought she saw a man crossing the street toward her. This looked like the same man! The dark figure was wearing a hat, and she saw that he was leaning against a neighbor's fence straight ahead, as though he were waiting for her to pass in front of him. Susie hesitated, but she told herself that there was nothing to fear from this man. He was probably out for a smoke or something. She strolled along the path toward her house. It was so dark now, and she could barely make out the outline of a person leaning on the fence. Why was the streetlight not shining on him? The tree must be blocking the light—yes, that's it, she reasoned. As she approached, he stood up and started to walk away. Susie saw his hat moving from side to side in tandem with his stride. A dog's bark startled Susie, and she turned around, looking for a dog. When she looked back toward the direction of the man, he had vanished. She had only turned around for a second, and during that second, this man was gone. Susie ran home and locked the door.

IS THE HIGH SCHOOL HAUNTED?

It is with true love as it is with ghosts;
everyone talks about it, but few have seen it.
—*Francois La Rochefoucauld*

Santa Paula High School was first built in 1915 and then modernized in 1936. It was built in the Mediterranean style at 404 North Sixth Street. It was designated Ventura County Historical Landmark No. 97 and is now part of the Santa Paula Unified School District. It was one of the many Roy C. Wilson Sr. designed. Many Hollywood films depict this high school, and in the movie *Carrie*, the high school was affected by the paranormal activity of the characters. Young couples would enjoy going to walk the grounds of Santa Paula High School because it was not only a beautiful campus, but it also sits on a hillside overlooking the city lights. A view such as this is very romantic, and under the light of the moon, it makes for a memorable moment.

A young couple took a walk up to the high school one evening in the late 1940s. Marilu and Joe enjoyed each other's company, and they had fun together because they liked the same things—movies, dinners, sports, hiking and reading everything. As they sat on a park bench in the main quad area that night, they noticed a dark figure standing in the far corner. They had the sense of being watched.

"Joe, I see him again," declared Marilu. "See, he's over there on the second floor watching us."

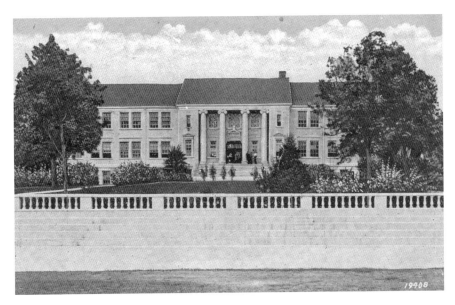

An early photograph of Santa Paula High School in 1915. *John Nichols Gallery.*

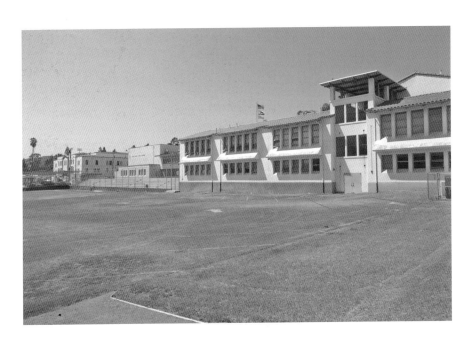

Santa Paula High School today. *Robert G. Jr.*

Joe stood up from the bench, and he turned to take Marilu's hand, saying, "Marilu, we must go now. I don't know who this guy is, and I better get you home." They turned toward the stairs, which exited the campus toward the front façade. Joe closed the gate behind them and continued walking. In front of them, they saw two dark shadows walking. Joe and Marilu were suddenly frightened. Marilu was shaking by this time. Joe grabbed her arm and turned her toward the open grassy field. "We must run toward the street—there's a gate down there. Don't look back, just keep on running!"

He sprinted off into the night with Marilu hanging on for dear life. Her legs kept up as well as they could, and when she remembered the dark shadow people, she ran faster. It was pure adrenaline fueling this couple's run. Fear, apprehension and no good explanation about the shadow people they saw kept them from falling. They were running for their lives.

They reached the south entrance and climbed over the low iron gate. Marilu slipped and fell onto the pavement. Joe rushed over and helped her to her feet. She was fine, she told him. They reached the chain-link fence around the perimeter of the school and made their way out of the gate and

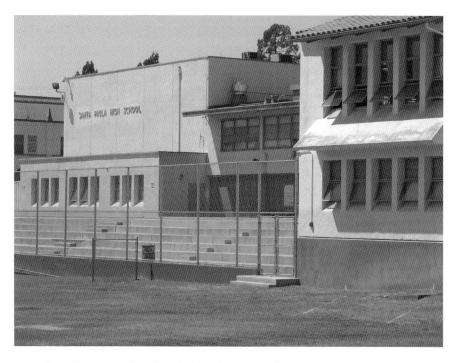

Santa Paula High School's main building, where many shadow people have been observed after dark. *Robert G. Jr.*

onto the street. A car's headlights were shining brightly in the distance, and it was just enough to illuminate a path for them to cross the street safely. They ran and finally reached Marilu's house a block away.

They were sitting on the porch trying to catch their breath. Marilu couldn't get the image of those shadow people out of her mind. Where did they come from? Why would they congregate out there? The porch light came on and invaded their thoughts. Marilu's mom opened the door and announced that Marilu should come in soon.

Joe explained to Marilu that he needed to go home and process all that just happened.

"Yes, I have to think, too," she repeated. "We can talk tomorrow, Joe. Sleep well and be careful." He kissed her goodnight and turned to walk toward his house down the street. Marilu watched him walk to his house, and she saw him go inside. With that, she felt relieved, and she turned around to go inside of her house. She opened her door to make her way in when out of the corner of her eye she saw a shadow of a person walk past. She ran inside.

Countless others have seen shadow people through their peripheral vision. They see the figure move out of the corner of their eyes, and then it is gone, only to disappear without a trace.

FILLMORE, CALIFORNIA

LA LLORONA

It is wonderful that five thousand years have now elapsed since the creation of the world, and still it is undecided whether or not there has ever been an instance of the spirit of any person appearing after death. All argument is against it; but all belief is for it.
—*Samuel Johnson, quoted by James Boswell*

It is an ill thing to meet a man you thought dead in the woodland at dusk.
—*Robert E. Howard,* The Hour of the Dragon

THE AZTEC LEGEND OF LA LLORONA

There are over two hundred different versions of the legend of La Llorona. These tales originated in Mexico and found their way to the Southwest— California, Arizona, New Mexico and Texas. The original tale came from the time that Hernán Cortés and the Tlaxcalan warriors captured the Aztec leader Cuauhtémoc and the capital of Tenochtitlan in 1521. Cortés had captured Moctezuma II and had him go forth to speak to the Aztec people. When the people became angry, they stoned Moctezuma II, killing him. That is when the Aztec people selected Cuauhtémoc as their leader.

After Cuauhtémoc's capture, Cortés also had him executed. Years earlier, Moctezuma II had received omens alerting him about a god from the east who

would be arriving in Aztlán soon. Moctezuma II and his priests tracked the comet traveling across the sky over several months, and it is legendary that it foretold the arrival of the "god" from the east. They saw fire in the sky and fire across the water. The temple of Huitzilopochtli (Mesoamerican deity of war) burned down, lightning struck one of the other temples, the water surrounding the capital city seemed to be boiling and they heard the cries of a weeping woman at night. According to Aztec mythology, it was foretold that Quetzalcoatl would arrive in the Aztec land. The Mesoamerican god Quetzalcoatl, also called the Feathered Serpent, is known as the god of intelligence and self-reflection. It was legend that Quetzalcoatl and his twin brother created humans. Cortés arrived on the coast of Mexico on Quetzalcoatl's birthday. Moctezuma did not want Cortés to advance to the capital city of Tenochtitlan, so he sent him gifts of gold and other items, and most importantly, he sent him twenty young Aztec maidens, hoping these gifts would appease him. Cortés picked Marina (who is also known as La Malinche, or traitor, in Mexican legends), one of these maidens, for himself, and she served as his interpreter.

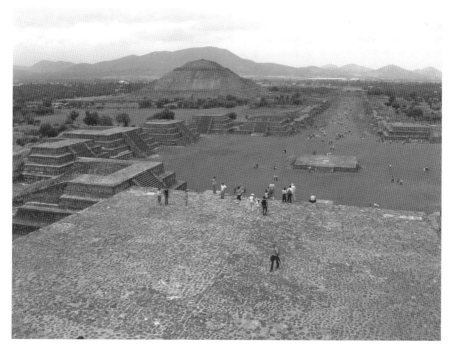

Teotihuacan is known for its majestic pyramids and is northeast of Mexico City. The largest structure at this ancient city is the Pyramid of the Sun. This ancient city in Mexico is shrouded in mystery, for it was built one thousand years before the Aztecs descended on it and named it Teotihuacan.

Hernán Cortés and Marina had a son together named Diego. Marina spoke Nahuatl, the language of the Aztecs, and the Spanish priest who joined them had been living among the Aztecs and spoke Nahuatl and Spanish. Marina would convey messages to the Spanish priest in Nahuatl, which he would tell Cortés in Spanish. Cortés responded in Spanish, and the priest would rephrase it in Nahuatl to Marina. This is how they communicated at first, but Marina soon learned Spanish and could speak directly to Cortés.

After seven years, Cortés told Marina he was returning to Spain and he would be taking their son. He planned to leave the following morning, and he instructed her to have him ready for travel. She wanted to go with him, and she asked him if he was going to take her. To this, he waved his arms and told her no. She pleaded with him to take her, but to no avail, for his mind was made up and he had no intention of taking her with him.

That night, she put on her Aztec headdress of gold and feathers and dressed in ceremonial attire. She made her son a very strong potion of tea leaves and other spices that would put him in a deep sleep. He drank the tea before bed, and as predicted, he fell into a deep sleep. Marina wrapped him up in a ceremonial blanket, and after midnight, she carried him to the large, sacrificial pyramid in the town square of the Aztec capital. She climbed to the very top, where she had left a sharp cutting instrument of carved obsidian and some tea earlier that night. After burning a powder on the sacrificial slab, she lay her son down, positioned him in place and took his life very quickly. He was in such a deep sleep that he felt no pain. She removed his heart and held it up to the heavens. Her deed was done. She drank the potion that she had left there for herself, and she fell asleep next to the body of her son.

At sunrise, Cortés's men saw Marina sitting at the top of the pyramid and the lifeless body of Diego laying on the sacrificial slab next to his mother. Immediately, Cortés's men rushed to wake Hernán and tell him what had happened.

"Cortés, your son is dead!" they said. "Come quickly!" They took him to *el zocalo*, the town square where the pyramids were, and he shouted at Marina, "Why did you do this? Why did you kill our son—my son?"

Cortés, a man of iron will and strength to match, was heartbroken. He shed one tear, and he asked his men to retrieve his son's body. As he waited at the foot of the pyramid, Marina let Diego's body roll down the steps of the pyramid, and it lay in a heap at the base of the glorious structure.

Instantly, Hernán Cortés felt the same way many of the Aztecs felt after having lost their children in battles with the Spanish conquistadores.

It was a grief he had never known. The sadness consumed him, and as he held his son, he vowed he would take revenge. Cortés instructed his men to wrap Diego's body and to prepare to take it on board the ship for burial in Spain.

Cortés left for Spain and took Diego's body with him. Marina remained all alone at the top of the pyramid until nightfall. The night was still, the moon was full and bright and the shadows of the pyramids were larger than life. Marina looked up into the heavens, and she recognized the brightest stars at that time. She suddenly realized what she had done when she saw the caked blood all over her Aztec ceremonial attire and the feathers that were blood-soaked—all with Diego's blood.

"*Mi hijo, mi hijo!*" (My son, my son!)" she wailed and cried as she climbed down the pyramid steps. She cried as she made her way through the streets. The Aztec residents were awakened by her cries, and some of the women rushed outside to comfort her, but to no avail. Marina walked through the streets, crying and wailing until sunrise.

The residents of Tenochtitlan were telling everyone what had happened. The residents in the neighboring cities heard the news as well. After midnight, many of the residents residing in the Aztec capital and neighboring areas heard the wailing cries of a woman as she searched for her son: "*Ayyyy, mi hijo, ayyyyyy, mi hijo…*"

Marina returned home at sunrise, and after collapsing on her cot, she slept through the day. The loud voice of an owl awakened her well past midnight. She rose quickly, looking for Diego, and when she could not find him, she went in search of him. She failed to remember what had happened the previous night, forgetting that she had sacrificed him at the top of the pyramid. She made herself the same strong tea, and its effects began to set in—the hallucinations and sadness prevailed. She cried through the streets as she searched for her son. Again, she was inconsolable. It was this night when she walked to the edge of Lake Texcoco and drowned. She had never learned to swim, and her body was recovered the following morning.

The residents continued to tell her story to all who listened. They also shared that after her body was found, some people claimed they had seen a glimpse of her walking through the streets at night. One lady claimed she heard her cries as she wailed, "*Mi hijo, mi hijo.*"

In the present day, many people now claim to hear her cries and to see her walking through the streets of what is now Mexico City and its environs. Others have seen her at the water's edge, and she has been reported to walk along the edge of creeks and rivers, crying for her son.

The story of Doña Marina, or La Malinche, is quite diverse. In her native Mexico, she is known as a traitor, hence the name La Malinche, because she served as Cortés's translator and is viewed as helping him overthrow her people. Others view her as a heroine, and her story has survived for over five hundred years. Cortés wrote very little about Doña Marina, but he did mention her in a letter to the king of Spain: "After God we owe this conquest of New Spain to Doña Marina."

Bernal Díaz del Castillo was a Spanish soldier and author who was a member of the expedition that conquered the Aztec empire. His book, *A True History of the Conquest of New Spain*, is his account of the Spanish conquest from the date of Cortés's arrival along the shores of what is today Vera Cruz in February 1519 to the fall of Tenochtitlan in 1521. In the book, he explains that Doña Marina was sold into slavery by her own mother, and then later Marina forgave her mother. There is much evidence to suggest that Marina was instrumental in reducing native casualties during the conquest because she negotiated peace treaties between the natives and the Spanish, thus saving many lives.

It is because of her loyalty to Cortés that many Mexican people think of her as a traitor. Others describe her as a diplomat and heroine. What really destroyed the Aztec population was not Doña Maria but the smallpox epidemic. They had no immunity to smallpox, and this destroyed their culture and people.

La Llorona Near Sespe Creek and the Santa Clara River

Monsters are real, and ghosts are real too. They live inside us, and sometimes they win.
—*Stephen King*, A Book of Horrors

There are numerous versions of La Llorona throughout Mexico and the southwestern United States. One legend tells about how the crying woman drowned her three and sometimes four children in the nearby river because she was despondent that her husband left her for another woman. Other tales mention the fact that after her husband left her, she did not have enough money to feed her children so she drowned them, and later she herself drowned after she realized what she had done. Parents will often warn their children to behave, lest La Llorona find them and take them with her to the river. This is often retold in Mexican culture. Other parents

La Llorona, the Weeping Woman, as sketched by artist Jeremy Leija exclusively for this book.

just repeat the legend of La Llorona because its a popular ghost story. The residents of Piru, Fillmore and Rancho Sespe often tell the story because someone they know has either seen her or heard her near Sespe Creek or along the Santa Clara River.

One of those sightings takes place in the Rancho Sespe area of Fillmore, along the banks of Sespe Creek and along the Santa Clara River. This is the tale the local residents tell.

It was a rainy night in 1978. This was the year of the flood, when the Sespe Creek overflowed its banks and inundated the surrounding area with water, debris, mud and whatever the floodwaters carried with them. Many homes were filled with mud from the nearby orange orchards, as well as oranges, rocks and debris. With the wind blowing, the leaves whipping and the raindrops crashing, the mind can play tricks on you; all sounds seem magnified. There were rainclouds everywhere, and the stars and moon were not visible throughout the region. One family who lived up in the La Campana Ranch area off Oak Street was struggling with a sick child. Their four-year-old son, Miguel, began running a fever, and his mom began to panic when the mercury hit 101 degrees. Isabel asked her husband, Salvador, to please go and get the *curandera* down the road or at least to ask her what they should do to help little Miguel.

Salvador knew what he had to do: brave the rain and cold and convince the *curandera* to come to the house. This was his son, too, and he knew the doctor would not come out on a house call on a night like this. No one in his

right mind would drive in this torrential rain. You could barely see what was ahead of you while on foot, much less in a car. Salvador put on two layers of socks and his work boots. He wore two shirts, a sweatshirt and a waterproof jacket. Isabel, his wife, found his knit hat and gave that to him. He went out the door with the flashlight, and even the dog wanted to go with him.

"No, Joaquin, you must stay here and protect the house," Salvador repeated. "OK, kids, I'll be back as soon as I can." Tomas stepped outside in the rain, and his flashlight helped him to see a few feet ahead of him. Everything was dark, wet and muddy. It was going to be a long night.

He made his way down the road past the six houses and then took a right to the house of the local *curandera*. The *curandera* is like the local herbalist; he or she knows which herbs to use to help cure certain ailments.

His boots were caked in mud, and his short raincoat was dripping wet. The raindrops fell down, randomly wetting his pants and boots. He opened the small gate and walked toward the house. He knocked on the door, but no one answered. He imagined they could not hear him because of the thundering rain. He tried again, this time with more force behind his knock. Still nothing. Then he knocked on the window, hoping that someone would hear him. Finally, the door opened, and the porch light came on, illuminating Tomas. *La curandera* was known as Doña Maria. She had four children of her own, and her husband also worked on the ranch with Salvador.

"Salvador what is it? You are soaking wet. Is everything all right? Come in, come in." Doña Maria was a kind woman and a very sensitive human being.

"No, Doña Maria," he said. "My boots are full of mud. Little Miguel is sick. His fever is 101, and he won't drink anything. He doesn't have an appetite. Isabel is using a wet cloth to keep him cool. What shall we do for him?"

"Stay here then, I'll be right back. I'll get some things together," Doña Maria replied.

She returned with a bag of herbs and other items and told him she would go with him to the house. She was wrapped up in a warm coat, shawl and scarf. She was wearing boots on her feet. She told her family she would be right back, and off they went into the driving rain.

Salvador tried to make sure Doña Maria was steady on her feet because of all the mud, but she was a pro. Her boots helped to keep her dry, and they gripped the ground like two suction cups. They walked past two of the houses now—only four more to go, and they would be there to see little Miguel.

Maria saw it first: the tall, slim figure of a person standing directly ahead of them. Salvador was shining the flashlight so they could see where they were going, and he saw what looked like a person, but then it was gone. Salvador and Doña Maria didn't pay much attention to what they saw because it had vanished. They rushed to Salvador's house just to get out of the rain.

Doña Maria went into the kitchen, and she prepared the herbal tea for little Miguel. After spending an hour helping Isabel with the child, both women were relieved when his temperature dropped to ninety-nine degrees. Miguel was finally sleeping as his fever had broken. Salvador and Isabel were so grateful to Doña Maria for helping them and their son. They paid her for the herbs, and they promised to take her some fresh vegetables on the weekend. Salvador had taken his wet coat off to let it dry out a bit before it was time to walk Maria back home. When it was time to go, something told him to take the large lantern so he could see farther ahead as they made their way in the darkness.

He assured his wife he would return within minutes. Salvador and Doña Maria stepped outside, and it seemed to be raining even harder. It was that blinding rain that forces you to close your eyes just so you can get a clear view of your surroundings. The water, mixed with the cold air, stung their faces. Maria clutched her shawl tighter around her neck and face as they quickened their pace, and finally they arrived at Maria's home. Salvador thanked her and saw to it that she entered her home safely.

Salvador turned around to make the short walk back home. He stepped off the porch, turned toward the main street and walked briskly past the first two houses. The lantern illuminated more of the landscape, and he felt better being able to see where he was walking. Yet straight ahead was the same tall, slim figure standing next to the fence. Salvador's lantern illuminated the person, who looked like a lady, soaking wet. She was wearing something black, her long hair was dripping and she seemed to have mud, leaves and twigs in her hair and clothes.

There was a faint odor of the river coming from the woman. The closest body of water was Sespe Creek. Had this woman walked all the way from Sespe Creek? Where did she come from and why? Where did she live? She didn't look familiar. Salvador thought he knew every family who lived at La Campana, but he had never seen this lady.

"Are you lost? May I help you?" Salvador tried to sound normal, but he was shouting so that he could be heard above the rain. He approached the figure cautiously so he wouldn't frighten her. His lantern was heavy, and it was wet.

The figure stood still, and all he could see was the darkness; he didn't want to startle her by shining the lantern in her face.

The woman responded, "I'm looking for my son. Have you seen my son? Someone told me he was here."

"I don't know your son," Salvador added. "What is his name? Where do you live?" Salvador was almost directly in front of her by now, and he was waiting for her answer when she slowly turned around.

He held up the lantern, and it illuminated a skeletal face—there were no eyes in the eye sockets, and the dark clothes she wore were torn and covered with mud. She stretched out her arms, and Salvador could see long, bony fingers as she took hold of his jacket and would not let go. Salvador yelled in terror as he struggled to break away. He avoided looking directly at her bony face without eyes, and at last he broke free of her hold. In his haste, he dropped the lantern, and it shattered against the fence. He rushed to his house, and without looking back, he forced his door open and stepped into the living room, still wearing his muddy boots and drenched clothing. He was certain she had followed him, and he kept the porch light on. No one else was nearby, so she had to be outside. He peered through the window to see if she was still outside, but the porch light illuminated the darkness and the falling rain. He didn't see anyone outside.

His wife rushed in to see what all the commotion was about. "Salvador, you look as though you have seen a ghost! What happened? What happened out there?" Isabel asked. She took out the good tequila, poured some into a shot glass and gave it to her husband. "Drink this, you will feel better in a few minutes," she said.

He gulped it down, and he tried to remain calm. He was terrified to step outside to remove his muddy boots and wet coat.

"Isabel, I'll clean up the mud later. You won't believe what I am about to tell you," Salvador said, and he told her the whole story. He told her how he and Doña Maria had seen someone standing close to the house when they made their way the first time, but the figure disappeared. He told Isabel what he saw when he approached the figure after seeing her a second time—she had *no face* and no eyes. She was a skeleton dressed in wet, muddy clothes. Her hair was long and stringy, and she smelled like the river. He was terrified just relating what had occurred.

Isabel looked concerned. "Salvador, you saw La Llorona. People have described her in this same way, and she cries for her son. She would come and take little Miguel if she could. She is said to have drowned

her son. Others claim she had two children and drowned both of them. Tomorrow, we are going to church, and we are going to bring the priest here to bless our house."

Salvador didn't argue with his wife. He struggled to understand what he saw. He could not explain it, yet he knew what he had seen.

There is another tale about the children who would go down to the Santa Clara River to play along the water's edge. During the summer, they would have fun catching the polliwogs and give a prize to the person who caught the most. Then they would bring the jars of polliwogs home and put them into a barrel of river water until they transformed into frogs. They enjoyed watching them daily as they swam around, and often the children would release the polliwogs back near the Santa Clara River. Many little frogs escaped on their own. It was common to hear the frogs croaking during the warm summer nights.

On this particular night, a group of three older boys decided they were grown up enough to go and smoke a few cigarettes on their own. They decided to leave the Halloween party that their sister was hosting for all of their friends. The plan was to slip away unnoticed about 10:00 p.m. and then return by midnight. Meanwhile, they enjoyed the festivities with their friends. Everyone had dressed up in a costume—some were ghosts, others were pirates and witches and there were several dressed as La Llorona. A group of friends came to play music, and there was dancing on the patio. Some were bobbing for apples, and others were just eating the apples. A good time was had by all. Everyone seemed busy with the party, so the boys took this as their cue to leave. Freddy, Marco and John grabbed their smokes, lighters and a few flashlights to take with them, and off they went toward the river. Marco was the most experienced one since he had been to the Santa Clara River many times. He knew the easiest and most direct path to follow. The boys followed his lead.

Their flashlights lit up the night, and the glow of the full moon illuminated the Santa Clara River. They could hear the rushing waters very close now. As they went around the bend, the water was within view. It resembled smoked glass. The ripples danced on the water, giving it new life. Instead of blackness, everything looked very gray thanks to the moonbeams. The boys enjoyed their freedom in this corner of the world. It was a place where they could smoke without being observed by their parents, and they could just talk freely with one another about anything. Freddy pulled out his smokes and lit up. The others were already puffing

away. Marco and John were reminiscing about growing up in this area and how they used to enjoy collecting the polliwogs and throwing stones into the water. Marco decided to take a short walk along the water's edge in search of some larger stones.

Marco walked along the now familiar Santa Clara River. He had been collecting stones since he was a child, albeit always during the daylight hours. He turned around because he thought he heard someone crying. It was coming from in front of him and not behind him. He hastened his step because he thought someone might need help.

What if it was one of the girls from the party? The party—he had almost forgotten about it. There was the crying sound again. Someone was crying, and she was nearby. Then he heard a loud wailing, and it terrified him.

"*Ayyyy, mis hijos…Ayyyy, mis hijos…*"

Straight ahead, he made out the figure of a person walking toward him. As the figure approached, he could see it was a lady dressed all in black. She seemed to have just climbed out of the river because she was dripping wet. When she saw Marco, she stretched out her arms and cried, "*Mi hijo, mi hijo.*" He knew who it was—it was La Llorona! He grew up with the story. His mom and grandma used to tell him about the crying woman, how she drowned her children and that she is forever doomed to look for them.

Marco turned around and ran. When he reached the boys, he yelled, "La Llorona, she's coming. I saw her, come on let's go!"

They saw her dark figure for an instant. She was in pursuit of Marco. Her arms were outstretched, and she was wearing something black. Her long, scraggly hair draped over her shoulders, heavy with mud and water.

"*Mis hijos…Ayyy, mis hijos,*" she cried, sending chills down the boys' spines. They were suddenly terrified. Never did they ever think they would come face to face with La Llorona, but that's exactly what they did this Halloween night!

They ran back to the party, and upon arriving on the patio, they must have looked horrific because their friends exclaimed, "What happened to you guys? You must have seen a ghost!" It was 11:55 p.m., and Marco knew All Saints' Day would be upon them in five minutes and they would be free of all the weirdness from La Llorona. As the boys told their story, two of the girls took two of the other boys outside to make sure La Llorona was gone.

They had their flashlights on, and as they searched the yard, they didn't see anyone wearing all black and dripping wet. As they found their way around the yard, the boys checked the bushes and still didn't see La Llorona.

Suddenly, Marisa, one of the girls, screamed and yelled, "She was here, look here on the fence!"

Everyone rushed out of the house when they heard Marisa scream. The flashlights shone where she was standing, and right next to her were muddy prints laced with small twigs and grasses from the nearby river— only the prints were not those of hands but only the bones from the hand. La Llorona had followed them, and she left her signature on the fence: her bony, muddy imprints.

Chapter 11

ST. FRANCIS DAM DISASTER

Ghosts crowd the young child's fragile eggshell mind.
—*Jim Morrison, "An American Prayer"*

At night, if you dare to walk along the Santa Clara River adjacent to the boundary of Rancho Sespe, chances are you will hear the sound of rushing water and screams of horror. When the St. Francis Dam broke in 1928, the water destroyed everything in its path. The lifeless body of a little girl was found wedged between some rocks in Rancho Sespe. Her mother was devastated, and residents claim they can still hear the mother's piercing scream. Others claim they have seen corpses of the dead walking along the river, for they do not know they are dead. The local residents claim that these walking dead are struggling to learn what happened to themselves in their desperate search for family and others familiar to them.

It was an eerie summer night, when a young couple, Bill and Linda, decided they wanted to see if they could see anything weird along the Santa Clara River. They had heard stories about ghost sightings and that the river is allegedly haunted. They were walking along the water's edge this clear night in 1955, and the stars and moon were on display in the sky. They were attempting to identify the visible planets and constellations. They picked out Orion and the Pleiades, as well as the North Star. They were tossing small stones into the river and trying to outdo each other to see who could throw them the farthest.

From the middle of the river, they saw a person's head pop up and then another and another. They had company; there were three kids swimming

A body recovered after the St. Francis Dam disaster. Many were so covered with mud that the Boy Scouts assisted adults in hosing them down so they could be identified. Some were housed at the Train Depot in Santa Paula and in other empty buildings. *John Nichols Gallery.*

in the Santa Clara River. The couple watched these young children as they swam. It appeared to be two girls and a boy. They seemed to range in age from ten to twelve years old. They were having a good time and laughing, as children do. The couple stepped away from the water's edge so they could have a better view of what was going on. Bill and Linda found some large boulders to hide behind, and as they perched themselves out of sight, they glimpsed the three swimmers climbing out of the Santa Clara River on the opposite edge. The cool night air didn't seem to bother them as they stood there, dripping wet. They were talking and laughing as they climbed over some rocks to reach the top of the rock formation right across from where Bill and Linda were hiding. A frog startled Linda, and she leaped out from behind the large boulder. Her shriek startled everyone. At that moment, the children turned around and noticed the couple. Upon seeing them for the first time, the children knew that this couple had been watching them. Without notice, Bill and Linda saw a mist envelop the three children, and they faded away before their very eyes, leaving behind the white mist.

The couple had never believed in ghosts until that night when they saw the three children's ghosts fade away. Who were they? They never found out, but others claim they were drowning victims and their ghosts still remain in this world.

STRANGE HAPPENINGS IN THE SESPE BACKCOUNTRY

The blind person never fears ghosts.
—Burmese proverb

Part of the folklore of the area includes the Sespe backcountry and the area of the Sespe Condor Sanctuary. The Sespe Condor Sanctuary was established in 1947, and it is north of Fillmore, California. In 1951, it was expanded to its current fifty-three thousand acres. The sanctuary lies within the boundary of the Sespe Wilderness, and the U.S. Forest Service maintains the refuge for protection of the California condor. Many tales of strange sightings and unexplained occurrences have taken place in this area behind Fillmore, Santa Paula and Ojai. Hikers have wandered in and never returned. Others fell down the steep cliffs, and their bodies were recovered days or weeks later. The land can be treacherous. During rainstorms, the water can rise unexpectedly, and flash flooding occurs. Hikers have been stranded, and some have lost their lives to the strong current of the Sespe Creek.

As one drives up Goodenough Road, on the left side is the drop-off of the cliff, and Sespe Creek is below. One night back in 1980, two boys decided they would drive off the cliff and end their lives. Joe Morgenstern wrote a October 1984 article, "The Death-Wish Kids," for *Vanity Fair* about this tragedy: "They got to Dead Man's Curve, with the cliff on the left…By the time they reached the curve, they were going fifty miles an hour…the car hit a dip on the shoulder…tilted its headlights toward the

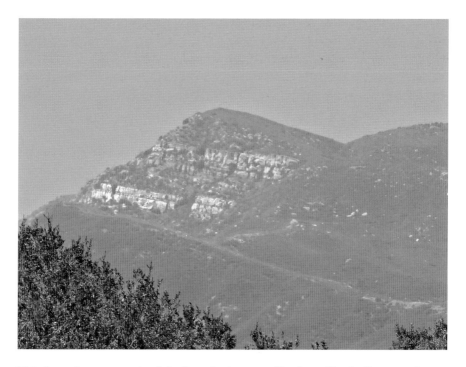

This shows the steep terrain of the Sespe backcountry. The Sespe Condor Sanctuary is located north of Fillmore in the TopaTopa Mountains. There are several trails hikers can take to access the area, including the Dough Flat site, which runs along the public corridor. *Robert G. Jr.*

sky…tore through the fence and went over the cliff. Then the car crashed, wheels up, on the huge glacial boulders of Sespe Creek, 350 feet below… one lived and one died."

There is also the tale of the lone hiker who enjoyed going up to Devil's Gate in the Sespe backcountry. On this fateful trip, he drove up Goodenough Road in Fillmore, and at the end of the road, there is a parking area for the hikers. He parked his jeep, removed his backpack and additional camping gear and led his dog, George, along the trail. Off they went toward Devil's Gate. Along the trail, the hiker stopped to photograph the scenery and the pristine countryside. There was water throughout their trek, and he stopped to let George drink. They made it into the Sespe wild, and he decided to set up camp. After setting up the campfire, they relaxed and lay back to soak in the night sky. It had been a good day, and both had eaten dinner and dozed off for a bit. This lone hiker decided it was time to take cover in their tent. He put out the fire and

Goodenough Road, looking down at the dry Sespe Creek below. This is at a distance of over three hundred feet. This is also near where a young man was killed, Jeff Westerberg. His friend, Joe Galarza, drove the car over the cliff. Jeff was killed, and Joe survived. *Robert Ybarra.*

packed up all the other stuff so they would be ready to hike to Devil's Gate in the morning. He could see it off in the distance, so it wasn't too far. He and George had been asleep when suddenly he was awakened by George's loud barking. He tried to calm him down. George was persistent, and there was no calming him down soon, so he stepped out of the tent to see what was going on outside. Off in the distance, he saw some white lights—three circles of light that were moving toward him. He had never seen lights like that out here in the wilderness, unless they were lights carried by other hikers. His intuition kicked in, and he decided to get back inside the tent. He and George were just waiting for these lights to disappear. At first, George waited next to his master, but then he started barking again. This time, the hiker peered out of his tent, and he saw the round white lights moving around much closer than before. They weren't lights from a lantern or spotlight; they were round and dancing above the ground on their own. It was as though they had a life of their own. They were silent and bright. He had no idea what they were, but they were orbs of light. He became frightened since he could not explain this phenomenon. He zipped the tent up tight, turned off his lantern and snuggled with George until morning. He barely slept the remainder of the night.

At first light, the hiker came out of the tent with George and looked around. Nothing was out of place, but George began to whimper. He was

sniffing around some large, round rocks on the eastern edge from where they set up camp. The hiker crawled down to see what George was trying to reach, and there next to the large rocks were three obsidian arrowheads. They were laid out in the form of a triangle, with the edges touching one another. They hadn't been there yesterday when he set up the camp. Many people claim that orbs are living spirits; did the orbs' spirit presence leave the arrowheads as a reminder that the Native Americans still protect the land? He left the arrowheads in position, and he and George left the camp. He didn't want to venture any farther; it was time to go home. He and George returned home, and they never went back to the Sespe wild.

In the 1969 flood, a group of boys and several men lost their lives when the swollen Sespe Creek made the roads impassable. They perished during the rescue attempt. Others have gone hiking in the wilderness, never to return alive. Bodies have been recovered after their disappearance. Most recently, an Arcadia firefighter, Mike Herdman, had gone hiking with his friend, and he had taken his dog with him, as he had done numerous times before. Only this time, the firefighter went chasing after his dog and didn't return. His body was located two weeks later, high on the edge of a steep cliff, and the coroner determined he had died of trauma from the fall.

Some of the Native Americans talk about the "skinwalkers" who inhabit the remote Sespe wilderness, and various hikers claim to have seen hikers who disappear behind rocks, only to emerge as a coyote or mountain lion. There is no proof of that, but a skinwalker is a man who has the ability to change into an animal shape. Others claim that the skinwalkers are part of the "curse of the Chumash" because the land was originally owned by the Native Americans, and it was taken from them by the white man. Many vow to keep the Sespe Wilderness wild, especially with the Sespe Condor Sanctuary in this area. Perhaps the spirits and skinwalkers are simply doing the same.

Johnny Cash started a fire in the Sespe backcountry in 1965 when his truck ignited the brush nearby. Known as the Adobe Fire, it ended up burning over five hundred acres, and he was fined for this accidental fire, which was located near where Alder Creek spills into Sespe Creek above Fillmore. Johnny Cash is a country music legend in Ventura County, as well as internationally. He enjoyed fishing in the Sespe area. They claim that people return to the areas they loved in life, and perhaps it is Johnny Cash's music that hikers have heard when hiking up near Alder Creek.

BURIED TREASURE

I don't mind UFOs and ghost stories, it's just that I tend to give value to the storyteller rather than to the story itself.
—Robert Stack

Rumors are rampant that the foothills of Fillmore, Rancho Sespe and Piru are filled with buried treasure. Joaquin Murietta, Tiburcio Vasquez and their men had allegedly buried their gold in the foothills of the Sespe backcountry. Their plan was to rescue their gold at a later time—only that time never arrived because the bandits themselves were killed and their cache of gold forgotten. They took their secret hiding places to their graves. No maps have ever been discovered, and if they existed, they were probably destroyed over the years. There is allegedly more gold buried in the hills of Piru and the Sespe backcountry.

The home where Josefina and Louis lived was haunted. After midnight one night, they were awakened by sounds coming from the backyard. When they looked out of their window, a dark figure of a man could be seen digging with a shovel, only in the morning, everything was back in its place. This man had been seen digging several times before. Louis had seen him a few months earlier and rushed outside to tell the man to leave, but when he reached the point where he had seen the man digging, no one was there. The second time the man was seen, Louis and Josefina both saw him, and they both rushed outdoors to find out who this mysterious man was and to find out why he was digging in their backyard, but he was gone.

This large sycamore tree is California Historical Landmark No. 756. In 1846, General John C. Frémont used the tree as a guidepost on his travels across the Santa Clara Valley. *John Nichols Gallery.*

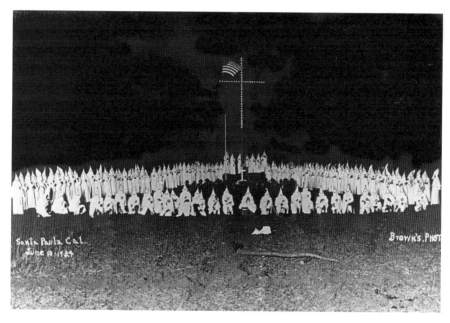

The Ku Klux Klan in Santa Paula. They met in the remote areas behind Santa Paula and Fillmore. In 1924, most everyone in the area was a member of the local KKK. *John Nichols Gallery.*

One day, a *curandera* (or healer, as they are known) told Louis that a legend had been passed down that one of the bandits returns and digs around the area as he is searching for his gold. When Louis or Josefina see the man digging outside, they assume it must be the bandit, who disappears before they can talk to him. There was never any evidence of anyone digging any holes on the property. Footsteps could also be heard throughout the house, but no one was there.

Sometimes when travelers needed a hot meal and a place to stay for the night, they would go to Louis's home in the outskirts of Fillmore. He often gathered his sons and daughters after their supper and told them stories that he had heard from these travelers.

Their house was two stories, and sometimes at night they would hear the floor creak upstairs. "That is the ghost of the man who lived here on this land before we built our house," their father would say. "He is trying to escape, but the house has him trapped." His daughters would laugh, and they attempted to ignore such tales. His sons reacted in similar fashion—until one night. The family was asleep, and the girls were awakened by the sounds of footsteps climbing the stairs. They jumped out of bed and dashed for the door. Their screams awakened their parents, and after Louis learned about what incited the screams, he took his lantern and looked around. All the commotion awakened his sons, and they, too, went searching through the house, but they did not find anything or anyone. Louis told them it was Tiburcio Vasquez searching for his buried treasure, and his daughters never discovered what caused the sounds of those footsteps climbing the stairs. They talked about that night, especially before El Dia de los Muertos—the celebration known as the Day of the Dead. The house was clearly haunted, and when they moved to another house in Fillmore, their haunted residence was demolished.

THE LADY IN WHITE AND THE SYCAMORE TREE

I like the ephemeral thing about theatre. Every performance is like a ghost—it's there and then it's gone.
—Maggie Smith

Over the years, people have shared stories about the area known as Oak Village in Rancho Sespe and the things children have seen there at night. One cannot verify what people say they saw, but the tales are shared anyway.

A group of high school students got together to serenade their mothers for Mother's Day. Two boys had their guitars, the rest were to sing, and after they made the rounds at the various homes at the ranch, they were to go to one of the homes for Mexican bread and Mexican chocolate—they loved *pan dulce*. This was a big deal and lots of fun. This particular year, the group of kids went serenading their moms, but two boys left the group. They wanted to go and look around the area along Sycamore Road. They had heard stories about the "Lady in White" who used to hang around the old sycamore tree. They took off running, and they decided they would be back in time to share the Mexican chocolate and *pan dulce*. They ran through the orchards and down to Sycamore Road, and they started running westward toward the old sycamore tree along Highway 126. There was a bright moon that night, so everything was illuminated in a silver light. The dirt along the edge Sespe Creek was damp, and it was getting cold. The jagged trees nearby looked foreboding, and all of a sudden, Tomas grabbed Ricardo's

shoulder. In a very shaky voice, Tomas stated, "Look, look straight ahead, over there—there's someone standing there!"

The boys were quiet, and they shielded themselves behind some citrus trees so they wouldn't be discovered. Each crouched down, and they observed a few cars passing along the highway. The tree was large, and they observed the Lady in White sitting on the wall near the tree. After the next car approached, she stepped off the wall and stood in front of a sycamore tree. The boys realized she wasn't a human being because they could see the road through her body. She was a ghost.

She must have known they were behind her because she turned around and started walking on Sycamore Road. When the boys saw her approaching, they were paralyzed with fear. Tomas opened his eyes wider, and his skin crawled as the perspiration and sweat rolled down his face and back. He imagined Ricardo must be just as fearful. The boys were terrorized because they saw this figure floating toward them. As she approached the citrus trees where they were hiding, they could see the mist all around her and under her feet. She was at least eight to ten inches above the ground, and she didn't have a face!

Frightened, Tomas and Ricardo took off running as fast as their legs would go. After running for almost ten minutes, they knew they were approaching their friend's house because they could hear singing and the strumming of the guitars. The group was already sitting around a table, sipping their Mexican chocolate. After reaching the group, the two boys collapsed on the lawn. Some of the girls jokingly said, "Tomas and Ricardo, where did you go? You two were gone awhile." After one of the moms gave them something to drink, they caught their breath long enough to describe what they saw: "We saw her, we saw her—we saw the Lady in White, and she didn't have a face!"

After that night, they never took off walking along Sycamore Road. Who knows what they truly saw—imagination can play tricks on the mind when it is dark and eerie.

Chris and Johnny were best friends, and they were just glad to get out of town this Friday night. The two nineteen-year-olds were leaving Fillmore in Johnny's car to join a party in Santa Paula. Johnny's dad reminded him to not drink and drive and that they needed to be home by 1:00 a.m. at the latest.

Driving down Highway 126 was always an adventure because it looked so spooky at night. They knew many people who had lost their lives on that treacherous stretch of road. Some were neighbors and friends, while others

The Lady in White, as sketched by artist Jeremy Leija exclusively for this book.

were relatives. Always a cautious driver, Johnny took no chances, and he wasn't the reckless type.

They arrived at their friend's party, which was held at the Glen Tavern Inn. It was a "sweet sixteen" party, and of course, they were looking forward

to meeting all the pretty girls. Dinner was served, and there was dancing, with a small band playing music. A good time was had by all. Chris offered to drive home if Johnny was worn out since Johnny danced nearly every dance at the party. He made sure he danced at least one dance with every girl in attendance. He was a gentleman in that way.

"Nah, man, I'm cool," Johnny said. "I can drive, but thanks, Chris. I'm not that tired. I especially liked that chick wearing that blue dress." Johnny was walking on air. The guys found their car and started the fifteen-minute drive home. The radio was blaring, and Chris was singing along—then both just burst out laughing. The "girl effect" is what Johnny called it. Love makes the world go 'round!

It was a quiet night, and it was a dark night. No moon was visible, and the stars were peeking behind a cloud-covered sky. The blackness was foreboding. Johnny knew he had better remain awake and alert. They kept the windows rolled down so the night air would instill him with a sense of vigilance while driving. As they approached the old sycamore tree, the road ahead looked so desolate, as though they were entering an existential tunnel of no return. Chris saw her first.

"Hey man, slow down," he exclaimed. "Look over there, to your left next to the tree—there's someone standing there!"

Johnny checked his rear-view mirror, and no one was behind him—only blackness. He was cautious, and he pulled over to the shoulder of the road as far right as he could. He was directly across the street now, and the girl standing next to the sycamore tree was clearly visible. She was dressed in a fancy white long cape with a hood attached. She looked so beautiful standing there, all dressed in white. The boys were mesmerized. Johnny didn't want to yell all the way across the road, so he made a quick U-turn. Now the car was directly in front of her. Chris stepped out of the passenger side and asked her, "What are you doing out here by yourself? It's not safe for you to be all alone. We can take you home or wherever you need to go, right Johnny?"

"Yeah, we wouldn't want our own sister to be standing out here," Johnny replied. "I'll drop you off wherever you tell me to go. Climb in—Chris, help her get into the back seat."

Chris held the back passenger door open for this beautiful girl, and she climbed in. Chris introduced himself, and he attempted to make small talk, hoping it would put her at ease. Johnny made another U-turn, driving eastward to Fillmore. Johnny joined in the conversation, and he told her his name and that he and Chris were coming from Santa Paula. Chris asked her if she lived in Fillmore and if that's where she wanted to be dropped off.

Johnny was quietly listening for a response, but there was none. Chris, who was sitting in the front seat, turned halfway around and started to talk to her when he let out a wild cry. Johnny couldn't understand what was going on, so Chris grabbed Johnny's shoulder and pointed to the back seat with his free hand. By now, Chris was unable to speak, and he was shaking like a leaf. Johnny slowed down, and as he checked in the rear-view mirror, he couldn't see anyone. It was an abyss of blackness. When he pulled over and stopped the car, he turned all the way around and saw the empty back seat. The girl was gone! The "Lady in White" had vanished before their very eyes. Chris and Johnny then understood what they had seen. It was the real Lady in White by the sycamore tree who had been sitting in the back seat! She was beautiful—and a ghost.

Johnny was going to be late getting home; it was already 3:00 a.m. He should have been home two hours ago His mom was waiting up for him when he got there. He stepped into the living room and asked him mom to please make him some coffee. In the kitchen, he always felt warm and safe,

The sycamore tree on Highway 126 and Sycamore Road where the Lady in White has been seen. The stone plaque sits in front of the tree. Various mementos sit behind the plaque in remembrance of those who lost their lives in traffic accidents near this landmark. *Robert G. Jr.*

so that's where he wanted to be at that moment. They were sipping coffee together, and Johnny told her the story. His mom didn't believe in ghosts, but she believed Johnny. He was her son; she knew he wouldn't lie to her for arriving two hours late.

The next day, Chris's mom went over to Johnny's house, and both moms shared what their sons had told them. Years passed, and people still talk about the Lady in White by the sycamore tree. Unfortunately, those two boys have passed away—much too soon. Chris passed away as a result of a traffic collision on Highway 126 when his car was hit by a drunk driver; Johnny was killed when his car slammed into one of the eucalyptus trees lining Highway 126 a few years after Chris was killed. The plaque in front of the tree where the Lady in White is seen used to read "Sycamore Tree California Historical Landmark No. 756" before it was removed by someone.

HIGHWAY 126 AND BLOOD ALLEY

Her soft trailing fingers would continue to attempt a connection that I refused to allow; that I couldn't allow if I wanted to survive.
—*J.D. Stroube,* Caged in Darkness

Before you reach the "hangman's tree," or the "old sycamore tree," as it is also known, one passes the little Red Schoolhouse on the right when traveling east toward Fillmore. It was constructed in 1907 and has been filmed in many commercials and featured in various Hollywood movies. It serves the community as a schoolhouse, but at night, the schoolhouse takes on a life of its own. People have seen unexplained lights turn on and off, and children's voices can be heard emanating from the building when it's supposed to be empty. No one is in school after midnight. During the daytime hours, it is a happy place—but beware.

After you pass the Red Schoolhouse, you will see the "hangman's tree" on the left, just a short distance down the road on Highway 126. This is where the Lady in White has been seen, and this stretch of roadway from Santa Paula to Castaic has been the scene of numerous accidents and untimely deaths. Aside from the intoxicated drivers who have caused accidents, sober drivers sometimes swerve into the oncoming traffic lane and cause head-on collisions. The tragedy is not just for those involved in the collisions but also for the families of all the victims. Many people are taken too soon. Numerous drivers along the 126 have reported seeing "ghostly" sightings alongside the highway. Without a full moon—or any moon—under a canopy of darkness,

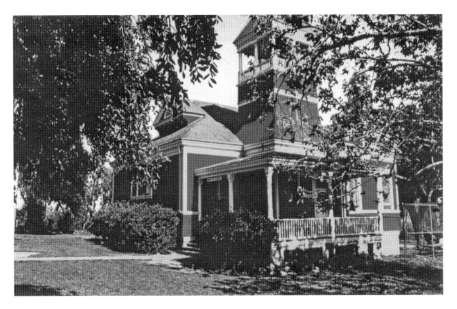

This is the Little Red Schoolhouse that sits between Santa Paula and Fillmore. It was originally built in 1907, and many children have passed through its doors. It is one of the few remaining two-room schoolhouses in California. *John Nichols Gallery.*

the tall eucalyptus trees that lined the Rancho Sespe segment of the highway appeared ominous and foreboding.

When Keith and Eudora Hull Spalding owned Rancho Sespe, it was Mrs. Spalding who had the eucalyptus trees planted on both sides of Highway 126 along their Rancho Sespe property. They enjoyed their plants, gardens, trees and flowers. Keith Spalding, heir to the Spalding family of sporting goods, was one of the most successful agribusiness ranchers from 1910 until his death in 1961. The couple hired the famed architectural firm of Green and Green to design the bunkhouses for the single Caucasian male citrus laborers. Small bungalows were built for families who worked on the ranch.

A couple from Fillmore, Scott and Joanne, have shared their experience of seeing the Lady in White along Highway 126 during one of their many trips along the eucalyptus tree–lined road. They were newlyweds at the time, and on this particular night, they were traveling eastward on Highway 126 on their way home to Fillmore after a night out with friends in Ventura. The hour was late—after 1:00 a.m.—and they were discussing how much fun they had with their friends and talking about the fabulous Italian meal they had all shared. Directly in front of them, a short distance ahead, their car's headlights caught sight of something white standing on the side of

A photo of Highway 126 and the rows of eucalyptus trees that residents claim were planted by Eudora Spalding because she loved nature in all its glory, from her lush gardens to all the trees. *John Nichols Gallery.*

One of the Rancho Sespe bunkhouses sits in the background. Keith Spalding had the various barracks built for the single Caucasian men who worked on the ranch. They passed their time playing tennis, among other sports. Single-family homes were built for the families who also worked on the ranch. *John Nichols Gallery.*

the road. Joanne spoke first, "What is that? Is that a person? It looks like a lady standing there dressed in something white." Scott slowed down as he approached the lady. The headlights illuminated her: she was statuesque, and her long white cape covered her from head to toe. She stepped onto the roadway and seemed to float across directly in front of the headlights. Her feet were not touching the asphalt. They were at least ten inches off the ground. Scott's eyes were huge, and Joanne's face was frozen in fear. Never had they witnessed someone floating like this. As she made her way across, the white cape became a mist and they could see through it. When she passed the headlights, she had already dissipated into nothingness. The Lady in White was gone! She had disappeared right before their very eyes.

Joanne rubbed her eyes and pinched her own cheeks to reassure herself she was awake and to verify that she saw what she saw. Scott pulled ahead to get out of the traffic lane and pulled over to the side of the roadway. After a few years, both could talk about it, yet they cannot explain what they witnessed.

FOOTSTEPS IN THE HALL

Now I know what a ghost is. Unfinished business, that's what.
—Salman Rushdie, The Satanic Verses

John and Betty lived with their two children, Nancy and John Jr., and Betty's mom, Rosa, in their house in Fillmore. After a few years, Betty's mother passed away. The family grieved for her and were saddened because they were very close. The children missed Grandma, but they understood that it was her time to go.

One Friday night, they had all stayed up late watching a Disney special, and the children fell asleep on the floor with their pillows surrounding them. They had showered early and put on their pajamas so they could settle down and watch television. John was asleep in his chair, and Betty fell asleep on the couch. Betty was awakened first. There was "snow" on the television screen, which meant the program was over and the station was off the air. In the 1960s, television stations would sign off after midnight or 1:00 a.m. Everyone else in the house was sleeping. Then she heard it—the sound of footsteps in the hall and the noise of a cane hitting the floor with each step. Her mother, Rosa, used to walk with a cane. It sounds just like Mom walking down the hallway, thought Betty. John woke up within moments. Betty motioned him to be still. They listened and heard the cane and footsteps again. They were coming toward them. Suspenseful as it was, John leaped out of his chair and went to the doorway leading to the hallway. He flicked on the light switch and saw an empty hallway. Nothing was there.

An image of an alleged haunted house where apparitions have been seen and heard. *Robert Ybarra.*

Another night, a few weeks later, everyone was watching television in the living room when they heard the distinct sounds of footsteps once again. The cane sounds followed. The children sat still with looks of shock and surprise.

"It's Grandma! She's come back," their daughter, Nancy, cried out. They were frozen in place, and it was Betty who went to the doorway this time. She peered down the hallway, only to find nothing.

As time went on, they became accustomed to the sounds of footsteps down the hall and the sounds of Grandma's cane as it hit the floor with each step. They thought they would never see Grandma—until one day Betty and Nancy were arguing. Mom didn't want her daughter going out to a school dance because of all the homework she had yet to finish that weekend. As the argument elevated to a shouting match, Nancy threatened to leave and go to the school dance anyway. She was willing to disobey her mother. Betty was standing in the hallway, in front of her own bedroom, and Nancy was three doors down, standing in front of her room, when the door to the guest room opened. Out stepped Grandma with her cane, as clear as day to mother and daughter.

Upon seeing Grandma, Nancy stopped shouting at her mother. Grandma Rosa took a few steps with her cane as she walked toward Betty. Within moments, she disappeared into thin air.

The women stopped fighting, never to argue with each other again.

Betty shared this story with family whenever the subject of spirits and hauntings was discussed. There is another tale that the family shared with others and the events also occurred at the same house. Grandma Rosa was celebrating her birthday in 1940, and all her siblings and their children attended this birthday party. They had an outdoor barbecue, and everyone was having a great time. After dark, the adults went inside the house to drink coffee and chat. The men were smoking their cigarettes in the front of the house, and the women remained in the kitchen and living area while the children were playing baseball outside in the street.

Rumor was that the green house on the corner was a haunted house. The children stayed away from that house because they claimed they would hear noises and see strange people looking out of the windows when nobody was at home in the house. During the baseball game, the ball was hit toward the "haunted" house, and the outfielder, David, had to go and retrieve the ball. He ran to the edge of the sidewalk and crouched down to search for the ball next to some bushes. He felt around the dirt where the bushes were planted, and suddenly, to his amazement, he found the ball. He looked up at the house, and since it was completely in the dark, he knew no one was at home, yet he had the uncanny feeling that he wasn't alone. There was some gravel along the flower bed next to the bushes, so he took a handful of the gravel and threw it toward the wall of the house. The small rocks hit their mark. Within a few seconds, something flung all the gravel back at him. A spirit, ghost, poltergeist or whatever it was threw the small rocks back at him, and he heard them fall all around him.

That was it for David. He ran toward his cousins and gave them back the ball, and he was terrified as he relayed his experience to them. His cousins had also heard the sounds of the small rocks hitting the sidewalk and the street. They never forgot this experience.

CHAPTER 17

THE OUIJA BOARD AND THE MISSING COED

Double double toil and trouble,
Fire burn and cauldron bubble.
—William Shakespeare, MacBeth, *Act 4, Scene 1*

On Halloween night, Kate, Carolyn, Cindy and Elizabeth decided to play with a Ouija board. Kate hosted the slumber party, and the other three girls were looking forward to enjoying their time together. Kate and Carolyn were transferring to a private, four-year college in Los Angeles after graduating from Ventura College with two-year associate of arts degrees. Cindy and Elizabeth were going to transfer to the university in Santa Barbara. Their other friend, Roxy, couldn't spend the night at the slumber party, but she would be joining the girls until 11:00 p.m. She had a family obligation the next day, so her parents were going to pick her up. Roxy was transferring to a different four-year school as well. These nineteen-year-olds were full of life; they loved being with their friends and enjoying all the activities that teenage girls enjoy. Elizabeth and Carolyn shared the same birthday, and that in itself brought them together.

Kate, Carolyn and Cindy drove to Fillmore to pick up Elizabeth for the party, and on the way back, they decided to find their French professor's house because they had a crush on him and they were going to try to TP his place. He was a dashing, handsome man, and all the girls adored him. He was smart and kind, and one could tell he enjoyed the French language.

"Yes, that's the place, because I remember that tree in front of his house," explained Carolyn. The girls were giddy and giggling because they were successful in locating the house.

"We have to go. Roxy will be arriving soon," Kate reminded the others. So off they went to Kate's house.

Kate ordered the pizza, Carolyn and Cindy set the table and Elizabeth put out the cokes and candy. The salad was already in the fridge, so when the pizza arrived they would take that out too. The doorbell rang, and Kate let Roxy into the house.

All were just happy to be together without any pressing homework or projects due immediately. They were free for the Halloween weekend. After the pizza arrived, they took out the salad and sat down to enjoy their Halloween dinner. The girls shared the week's events with one another, and they got caught up on their latest love interests.

Kate took charge and emphatically stated, "OK girls, its time to go and TP the house! Let's go!" The five of them climbed into Kate's five-seat sports sedan and took off with twenty rolls of toilet paper. It was already 10:00 p.m., so they had to hurry. They parked down the street and walked toward their professor's house as they carried the toilet paper. They resembled the others who were trick-or-treating in the neighborhood.

"All right, Cindy, you and Roxy take that side, Elizabeth and Carolyn, come with me!" Kate directed. They split up and went about unrolling the paper. The house was dark, which was a good thing, because they did not want to get caught. Roxy covered the tree, and Cindy wound the white paper around the mailbox. They they wound it around the posts on the front porch. Elizabeth and Kate unrolled it onto the bushes surrounding the house. Carolyn threw a few rolls onto the roof, and they unrolled as they fell down the opposite side. The neighbor's dog started barking, and then another dog joined in.

"OK, girls, we better go," Carolyn was adamant. "Now! We cannot get caught doing this." They grabbed their bags and left the house covered in white. Off they went to the car, giggling and laughing all the way back to Kate's house.

The girls settled into the family room. Kate brought in the Ouija board, and they gathered around it on the floor. Cindy lit two candles and turned out the lights. They started to play. Everyone was enthralled because the planchette seemed to be moving on its own. Deep in thought, Roxy and Cindy were playing it and asking questions. The planchette moved around and responded YES and YES again. Suddenly, the doorbell rang. It was time

for Roxy to go home. After they said their goodbyes, the other four girls took turns playing with the Ouija board. Kate explained that everyone has their own Ouija and that's who speaks to you and gives you the answers. Kate knew a great deal about the Ouija board.

Each girl asked it to tell her the name of her own Ouija guide and when she would marry. It didn't reveal when each girl would marry, but it did spell out the name of each girl's Ouija. The grandfather clock chimed twice, announcing it was 2:00 a.m. At that, one of the candles seemed to flicker, and the light dimmed. The girls were just getting warmed up; they didn't want to stop because the board was going wild and answering all of their questions. When Cindy and Elizabeth were playing, the planchette seemed to be moving on its own. It went to the left, then right, spelling out the answers.

Finally, sleep set in, and the girls went to bed at 6:00 a.m. After sleeping all morning and into the afternoon, they woke up and had breakfast at 2:00 p.m. They showered, dressed and started their day by driving back to Fillmore to drop off Elizabeth. The girls said their farewells, and all agreed they had had a fabulous time and would plan on doing it again soon.

Cindy had a part-time job at the Broadway Department Store, and on this particular Monday, her mom was visiting Cindy's older sister, who had just had a new baby. Their mother was helping her oldest daughter for a few days with the baby, and then she would return home. It was a busy time for everybody. The next morning, Cindy was going to take her biology final, and after work, she intended to review her biology notes. She worked in the downstairs jewelry department, and her smiling face always attracted customers. She was kind and respectful, and she wasn't a pushy salesperson. Her public persona was a breath of fresh air for everyone she met.

At 9:00 p.m., the store closed, and everyone was busy turning in receipts and following the nightly ritual. Finally, Cindy was finished. Her car was parked out on the edge of the parking lot facing Main Street. Employees were asked to park a distance away in order to make room for the shoppers' cars. She clocked out and walked to her car. She was shocked to find it had a flat rear tire. She had no idea how to change a tire. Then a man came by and said he would help her. He put the car up on a jack and proceeded to remove the tire. At this time, a group of co-workers drove by and stopped and motioned to her that they were going to have coffee at the Red Balloon Coffee Shop, just a short distance from where the employees parked their cars. Cindy waved them on, so they left without her. They would often go there after closing time and just socialize. The girls were all college age, and

they just enjoyed socializing together. It was somewhat foggy that Monday night, January 20, 1970, and they could see Cindy was busy. Her car was up on the jack, and a man was standing next to the car. Later, when questioned by the police, the girls described this man as being in his early thirties and about six feet tall and thin. They noticed there was a light-colored car parked next to hers. This was about 9:20 p.m., and the girls went in to have coffee. They left the coffee shop at approximately 10:15 p.m. and decided to drive by Cindy's car to see if she was all right. Her car was still up on the jack, but Cindy, the man and the light-colored car were gone.

On January 21, Cindy's father, Leonard, woke up early. All the lights were on in the house. He got up and checked on Cindy, but she still wasn't home. It was already about 4:00 a.m. He jumped into his car and drove over to the shopping center. He saw her car up on the jack, but no sign of Cindy, so he called the police and reported his daughter missing. The police department sent over two officers, who surveyed the scene and explained that they had to wait twenty-four hours before they could search for her since she was over eighteen and considered an adult. They sent over two detectives as well to determine what may have happened.

In the meantime, Cindy's dad began making phone calls. He telephoned Cindy's friends in the neighborhood, hoping she had gone to one of their houses for the night. Cindy was very responsible, and she would not have done so without letting her parents know first.

The official flyer released by the Ventura Police Department informing the public about Cindy Mellin and her disappearance. *Ventura Police Department.*

After twenty-four hours, the police department began questioning Cindy's co-workers and her friends. They asked anyone with information to please come forward. Days and weeks passed, and there were a few false leads, but still no Cindy. They were back to square one. Cindy's mother and father went so far as to hire a well-known psychic to help them locate her, but he didn't offer anything new. As time passed, Cindy's friends graduated from college and went their separate ways.

Five years after Cindy disappeared, her mom passed away from cancer without knowing what happened to her daughter. Cindy's father never gave up hope, and he continued to look for her until he passed away.

The department store was sold to another retailer, and it was remodeled and modernized, yet store clerks and customers would see a young woman throughout the store with short blond hair who seemed to match Cindy's description. Another employee was in a stockroom sorting through merchandise for display when something pushed her against the wall. She was working alone, and she freaked out and came running out of the stockroom. She refused to go back in alone. Other employees shared similar experiences.

One night, about thirty years after Cindy's disappearance, a young man was closing up his department when, out of the corner of his eye, he noticed someone going up the escalator. He turned around and saw her: she had blonde hair styled as a short page boy, and she wore a navy blue dress. He told his boss, and his boss called security because the store was already closed. The security personnel searched the second floor. They spent thirty minutes searching for the mysterious lady, but no one was found. Others have reported a woman going up the escalator after closing, and she is described as wearing a navy blue dress. No lady is ever found.

Another incident involved the cleaning crew. One night, while the various departments were closing up the store, one of the store's housekeepers was cleaning the glass display cases when she heard the loud crash of something falling onto the tile floor. It sounded close to where she was working. She wandered over and found a jewelry display case was open and merchandise was strewn all over the floor. She immediately called security, who came and checked everything. They assumed someone forgot to lock the case, and somehow the merchandise was probably knocked over. They couldn't explain what happened.

The next night, the housekeeper at the department store was following her cleaning schedule when she heard a loud crash once again. She telephoned security, and they again assessed the scene and filed their report. This time, the manager of that department was in the store and explained how he had personally checked and locked all of the cases himself. With this information, the housekeeper was too frightened to continue working there, and she quit. The housekeeper now manages her own housecleaning business.

Thirty-five years after Cindy's disappearance, the girls who spent that Halloween night playing with the Ouija board with Cindy got together

and compared notes about their lives What was so peculiar is that all three girls had been plagued by someone who would call them anonymously and try to talk to them on the telephone. It wasn't just one or twice—it was a real stalker, and after the girls compared notes, they admitted they were terrified because this man would still call them even after they had their telephone numbers changed and they were unlisted. These calls started within a year of Cindy's disappearance. They were relieved the calls suddenly stopped after about six years, yet they were wary of strangers calling. By the time the women met up and compared notes, they had cellphones and unknown callers were not a problem.

Kate, who had hosted the Halloween party, confessed that about a year earlier, she had been awakened by someone tugging at her feet.

"It was Cindy," Kate insisted. "She stood there pulling on my feet through the blankets, and when I awoke, I was surprised to see her. She sat down on the edge of my bed, and she told me not to worry about her because she was dead, and she told me someone she knew had killed her. Cindy told me that we all knew this man and to beware of men who seem 'nice' because they could be killers. She explained that he was supposed to take her home to get her father, but instead he tried to have his way with her and he then killed her because she tried to escape. She appeared as the way I remember her, then she was enveloped by a grayish-white mist and she disappeared."

The other two friends were speechless. If that was indeed Cindy, then she was dead. The girls vowed never to touch the Ouija board again, and they often wonder if the Ouija was somehow responsible for Cindy's demise. They had often wondered if Cindy had been murdered that night in January by that man who feigned helping her with her tire. Her remains have never been found. The police determined that the tire had been deliberately slashed. It is speculation that the man the co-workers saw standing next to her car that January night was the same man who slashed her tire. It was premeditated so he could convince Cindy to go with him. Did he offer to drive her home so she could tell her father about her tire? The girls asked Kate why she never revealed that she saw Cindy's apparition. Kate explained that she hesitated to share what she saw because she had no logical explanation and she did not want to appear as a kook or crazy person.

One thing is certain: the girls never touched the Ouija board again.

BARDSDALE, CALIFORNIA

TALES FROM THE BARDSDALE CEMETERY

The moon is hidden behind a cloud…
On the leaves is a sound of falling rain…
No other sounds than these I hear;
The hour of midnight must be near…
So many ghosts, and forms of fright,
Have started from their graves to-night,
They have driven sleep from mine eyes away;
I will go down to the chapel and pray.
—Henry Wadsworth Longfellow, "The Neighboring Nunnery"

Be hole, be dust, be dream, be wind
Be night, be dark, be wish, be mind,
Now slip, now slide, now move unseen,
Above, beneath, betwixt, between.
—Neil Gaiman, The Graveyard Book

One of the most haunted cemeteries is the Bardsdale Cemetery on the outskirts of Fillmore. Roy Surdam helped establish Bardsdale, and the Bardsdale Cemetery Association was established on June 1, 1895. After the St. Francis Dam disaster, twenty-eight people were buried here.

When you go to Bardsdale, one must travel over the Bardsdale Bridge, which crosses the Santa Clara River. Many lives were lost during the St. Francis Dam collapse, and to this day, people have seen apparitions of ghosts,

This is the gated entrance to the Bardsdale Cemetery, and it still remains there to this day. *Author's collection.*

and they continue hearing unexplained cries after dark. The devastation is evident in the photograph on the next page of the destruction of the Bardsdale Bridge on March 13, 1928.

The high school kids would gravitate to the cemetery at night just to wander around and see what was out there among the graves and tombstones. Many of them claim to have seen ghosts and other unexplained apparitions that disappear within moments. Bardsdale Cemetery is home to white mist apparitions at night. One frequently reported sighting is that of a lady dressed in a white, flowing gown sitting on one of the tombs. When she is approached, she disappears before the eyes of the witness. Others have heard voices of children, as if they were playing nearby. Many of these disembodied spirits talk and laugh. Others are quiet.

One night, a group of high school students wanted to prove how brave they were, and they decided to go to the cemetery at night to wander among the graves and tombstones. They had to park their cars outside the locked gates and make their way into the cemetery grounds. Jack was the most daring, and he cut the locks on the gate.

He made way for his friends, and off they went. They had their flashlights, and one of the girls brought cookies in the shape of

After the St. Francis Dam failure, the people gathered in Bardsdale after the Bardsdale bridge had collapsed and the search for survivors continued. *John Nichols Gallery.*

tombstones; another brought cokes and sweet bread. They were ready to party with the dead and departed.

The teenagers came prepared, and one of them used his tools to unlock the front gate. Several went back and drove their cars to the back of the cemetery, where they couldn't be seen as readily by anyone passing by at this late hour. They shut the gate and left it unlocked. Once inside, they laid out their blankets, took out their food and drinks and started eating. They had never had a midnight feast in a cemetery before, so this was a first. When Ed saw something in the distance, he cried out, "Look, over there by that palm tree! Someone is watching us." He managed to stand up, and the others were shocked into the reality of the situation.

"I see a dark figure next to that tree and it's trying to hide behind that tall tombstone," he said. The others stopped eating and peered in the direction Ed told them to look. "I see something else moving," Ed repeated, getting very nervous.

Frankie confirmed what Ed was saying, replying, "Yeah, look over there behind those trees, the ones closest to the road—something moved." The girls were getting nervous, and they didn't want to eat anymore. The others were silent, but they were observing and trying to make out what it was they were watching. Out from behind the large tombstones near the entrance to the cemetery, dark figures were moving around from one side to the other

as if they were all going somewhere. They were approaching the group of teens. The shadows were running from one tombstone to the other and from tree to tree. This is it, Kelly thought. "Hey, let's get out of here," she screamed. "Leave all the stuff!"

They all ran to the nearest car or truck. Melissa was petrified with fear and frozen in place. Larry grabbed her arm and pulled her, which startled her out of her trance. They got her into the car quickly, and Larry closed the door. He ran to his truck and screeched the tires as he turned around. He could see the shadows darting everywhere. There were so many of them. His headlights only made them invisible, but they were still there lurking about. They remembered they had shut the gate but left it unlocked.

"It will open when you push it with the truck. Just do it a bit slowly so you don't damage it," Ed was adamant when he told this to Jack. When Jack slowed down to make it through the gate, the shadows were approaching the truck. They looked like people all dressed in black. Jack's truck was the first one out of the gate, and he waited alongside the street until everyone else made it out. The rest of them climbed out of the truck and car and got into their own cars they had left alongside of the road. Once inside their cars, all were too terrified to drive. As they were sitting there with their engines running and lights on, they could hear the distinct sound of screeching tires and a very loud rumble. Someone's engine was racing through the rpms, and the hum changed octaves as the engine changed gears. The sound was so loud—who would be racing at this time of night? Then a horrendous crash interrupted the engine's hum. What was that? Jack and Ed drove their truck in the direction of the sound, and the others followed. As they searched for the car, they realized they were being led on a wild goose chase; there was no car and no accident.

Frankie told the group that maybe what they heard was an accident that had happened years before. The kids knew this was enough for one night. It was time to go home.

In the weeks that followed, they spent hours in the library searching for meaning to what they witnessed that night. They became more serious about their lives and their future. Ed found the archive that discussed the accident they had probably heard happen. A twenty-five-year-old was trying out his new Corvette Stingray, and his best friend was in the passenger seat. The young driver underestimated his new car, and he didn't negotiate a curve and the car crashed into a wall. The fiberglass body disintegrated, and both men lost their lives in Bardsdale, California, that day.

Never again did the high schoolers visit the cemetery at night—or even during the day!

The Lady of Chambersburg Road

Of all ghosts, the ghosts of our old loves are the worst.
—*Sir Arthur Conan Doyle,* The Memoirs of Sherlock Holmes

Several residents have seen the Lady of Chambersburg Road walking along the edge of that street at night. One man was returning home after a night of reminiscing and drinking a few beers with his pals. He had four cups of coffee before he commenced his drive home to Bardsdale. After saying goodbye to all of his friends, he jumped into his pickup and drove down Highway 126 toward Bardsdale. He crossed the Bardsdale bridge and proceeded on to Chambersburg Road. What was that next to the road? His headlights caught the figure of a person standing alongside the edge of the deserted road. He slowed down, and as he approached, this figure was almost directly in front of his truck. He watched it glide across the road to the other side. His eyes were wide, and he was breathing all right, but he was terrified. This was a lady who was made out of a white mist. She didn't seem to notice him in his truck when she crossed in front of him. That does it, Jonathan thought to himself. I'll never drink again if I have to drive home by myself. He drove a bit farther and made a U-turn to swing back around to see if she was still there. As he retraced his route, he didn't see anything unusual. He didn't see the lady in white. He says he will never forget his experience that night.

Jonathan was on his way to his house on Pasadena Avenue in Bardsdale. There are reports from various people in the community that Jonathan's

house is haunted. One of his relatives died in the upstairs bedroom, and they claim that there is a bloodstain on the hardwood floor that won't disappear. His family hired workmen to clean the floors, which were stripped and some of the wood was replaced, but to no avail. The blood stain reappeared. They covered the floors with new carpeting, but that wasn't enough because the blood reappeared as a stain on the carpet. His relative died of a stroke, and when she fell, she hit her head and bled onto the floor. It was too late when she was found, and she passed on. It is at this same house where others have seen unexplained occurrences.

A photo of Chambersburg Road showing the palm trees that were planted in the early 1900s. *Robert Ybarra.*

SHADOW PEOPLE INSIDE THE HOUSE

The more enlightened our houses are, the more their walls ooze ghosts.
—*Italo Calvino,* The Literature Machine

As the story goes, Janice went to visit her friend in Bardsdale because the two were working on a school project for their history class. Janice drove over, and following Carla's written directions, she found the house. It was a lovely two-story Victorian home that had been restored. The house was located on Pasadena Avenue, but as of this writing, it is no longer standing. It was set back from the road, and there was a long driveway leading to the front of the house. As soon as she stepped into the house, Janice sensed something unusual, and she felt uncomfortable. She couldn't understand her reaction, and she asked Carla for a drink of water.

Carla led her into the sunny kitchen, and she took out a pitcher of lemonade from the refrigerator. Carla was chatting away about their school project and about the special maps she had acquired for the poster they had to make. Janice sipped the lemonade and began to feel more comfortable. Soon she, too, was chatting about her contribution to their project. They were soon laughing and enjoying this respite of girl time.

"OK, let's get to work, Janice," Carla said. "I have poster board and markers set up in the dining room." Janice was happy that she was working with Carla because she was so organized. The two took their glasses with them into the dining room and began to lay out their maps and various documents that would become part of their project. In the dining room, on

An example of the Victorian homes in Santa Paula and other communities that allegedly house resident ghosts. *Robert Ybarra.*

the wall over the mantel, there was a large mirror. Janice could see her own reflection in the mirror, and she noticed that she needed to get some new glasses—these frames looked a bit dated. Carla was organizing the layout of her poster, and she told Janice she was going to get the glue from her bedroom upstairs. While Janice was waiting for Carla's return, she decided to brush her hair in front of the mirror. Her dark hair was long, soft and shiny, so she tied it back with a ribbon to keep it out of her eyes. She was putting on her lipstick when she saw a figure of a woman pass across the doorway. She didn't think anything of it as she assumed it was Carla's grandmother.

Carla came bouncing into the room with the glue, scissors and some pieces of wallpaper that they could use to dress up their posters. Janice told Carla about the figure of the lady she saw in the mirror.

"I saw your grandma," Janice exclaimed. "She walked past the doorway when I was brushing my hair."

To this, Carla responded, "No, nobody else is here in this house. We are the only ones here. My grandma passed away last year, so it's just my mom and I who live here."

Janice didn't say anything, and Carla asked her to describe the woman she saw. Janice paused a moment and responded, "She was wearing a dark-colored dress with a cream-colored shawl over it, and her hair was short and gray."

Carla said, "That sounds like my grandma. She wore a shawl all the time, and her gray hair was styled short. I wonder if she was really here. I've heard of people coming back to the places they loved the most." Carla was puzzled. She hadn't seen her grandma in this house, but her friend was claiming she has seen someone who resembled her grandma.

"Let's get some cookies! I'm hungry," Carla said. "C'mon, we need a break, and my mom baked some oatmeal cookies this morning." Carla led the way, and the girls stood around the kitchen island snacking on the homemade oatmeal cookies when Janice saw someone pass through the kitchen out of the corner of her eye. It was a dark figure, and it moved quickly.

Then Carla saw it. She was placing some cookies on a plate to take into the dining room when she screamed, "Who's there? I saw someone walk past me toward the pantry. Janice, is that what you saw?"

"Yes, it seems that we aren't alone in this house," Janice replied. "You have others here with you. What happened in this house?"

Carla responded, "Grandma died in this house. She had a stroke, and she used to sleep in the upstairs bedroom. That's where she died." Janice suggested they had enough to finish the poster, and she volunteered to take it home and add the finishing touches to it. Carla agreed, and after they cleaned up the kitchen, Janice left. She was uncomfortable in that house. It was eerie because she had sensed it as soon as she arrived, and that's before she had heard the story about Janice's grandmother dying in the house.

There is another tale of shadow people who surround an old house in the city of Fillmore. This particular house had sold, the new owners were moving in and not everything had been unpacked and put away. This house had been moved from the Bardsdale area to its current location in the middle of town. On this particular night, the family had gone out to dinner, and when they returned, they decided to save the unpacking for the following day. There was the living room with a huge picture window facing the street, and there was a hallway behind the living room that went parallel to it. On the far end of the hallway was the door to the master bedroom. It was a sunken bedroom, which made it very cozy and set it apart from the rest of the house.

On this particular evening, the children were asked to spread out their sleeping bags on the carpet in their parents' bedroom. They could all sleep as a family tonight since the children's beds hadn't been set up yet. After everyone had showered and put on their pajamas, they sat around sharing a few family stories since their television hadn't been set up yet. A night without television was unusual for them. After the last goodnight, only the

sound of Dad's snoring kept their mother awake. She lay back against her pillows and tried to shut her eyes, but she couldn't. She noticed shadows moving across the doorway leading from the bedroom through the living room. It looked like a group of people was congregating outside.

She was very curious, so she had to go and take a look. She stepped into the living room, and she saw shadows of people walking in front of her house. They appeared to be walking on the sidewalk, so there must be a party or some other gathering, she thought. She stood next to the window and moved the curtain aside so she could peek outside. To her surprise, there wasn't anyone outside. She assumed they must have gone elsewhere, so she turned around and went back to bed. Outside, the streetlights shone brightly, and she felt safe here.

Once again, she tried to get back to sleep. She leaned against the pillows and closed her eyes, but sleep would not come. Something was nagging at her, urging her to get up. She made her way back to the living room, and before she could sit down on the sofa, she saw them again—more shadows. These shadows were as before—moving back and forth across the sidewalk as though these people were walking somewhere. She was beginning to get nervous. Who were these people—neighbors or visitors of neighbors and where would they be going? She stopped to count them—there goes two, three, four, five—all walking toward the west side of the street. Next a few more, but this time they were walking eastward. Then there were three walking back. She sneaked over to her window and peered outside but saw nothing—nada. No one was outside. She couldn't explain what she was seeing.

Now she sat next to the window, and she waited for the shadows. They came. As they were moving, she pulled back the curtain so she could watch them, but when she did so, no one was outside walking. If there was anyone out there, they were gone. This was most unsettling.

The following night, their daughter wanted to sleep on the floor in their bedroom because she was still trying to get accustomed to this new house. Everything seemed normal, and there weren't any shadows walking back and forth past the living room, so the mom was more comfortable.

About 3:00 a.m., the daughter, who was about ten years of age, woke up from a sound sleep. She heard her dad snoring, as usual, and she could hear her mom's gentle breathing. Then she felt someone touch her back, poking her on the back shoulder area. She was frightened because no one else was in the room but her parents, and they were asleep! She froze, unable to move because she was petrified. Then it touched her again—whatever it was.

She rolled over onto her back and made out a dark figure standing at the doorway. She screamed! Her parents woke up immediately upon hearing this horrible reaction to fear. Dad turned on the lights, and Mom comforted her daughter, who was crying by now. She told them what happened, and she described the dark shadow of a person she saw standing in the doorway. Both tried to reassure her it was a dream—until her father saw the dirt outline of two large footprints on the new carpet.

Her mom believed her because of the shadow people she had observed walking past the living room window the previous night. The family remained in that house for a few months but eventually moved away because the shadow people visited the house each night, terrifying the family.

Another house that many allege is haunted is a rather large house in the center of town near Saratoga Street. There was a sleepover with about seven middle school boys and three adults. They were there working on a school project, and they were going to share their findings with their leadership class, which was the student government class of the school. They had barbecued their dinner and were sitting around eating dessert when one of the parents suggested he light the fire in the fireplace. All of them were enjoying the camaraderie of sharing ideas and solutions to various school activities. They were nibbling on s'mores and popcorn. The fire was very cozy, and that seemed to make the chocolate in the s'mores irresistible. They were laughing about various things that had happened, when out of nowhere, there was a loud knocking coming from the upstairs rooms. They looked at one another, puzzled about who would be upstairs knocking. Everyone was here in the basement—now it was a den/man cave.

"I'll go and see what's going on," said Dan, who owned the house.

"I'll go with you!" Steven assured him.

The knocking continued. David, the third parent, stayed with the boys to help keep them calm. Dan and Steven climbed the basement steps toward the first floor of the house. Everyone heard the door open, and the men stepped out on the main floor of the house. What was that knocking, and where was it coming from?

Dan rushed toward the kitchen when they heard pots falling on the floor. Steven was right behind him.

"Whoaaaaa…look at this! Look, do you see that?" Dan was almost yelling. Steven was wide-eyed, frightened and nervous. Nothing trained him to confront something like this. In the kitchen, they saw the cupboards opening, and something was throwing the pots and pans on the floor. Next, the pantry

door opened, and canned goods stated falling off the shelves. Dan's instinct was to get out of there and close the door. Both men ran out of the kitchen and down to the basement. David and the boys heard the crashing sounds from upstairs.

Dan burst into the room and described what he saw. Steven explained that it was beyond belief, and they all agreed they had to leave the house. The realization set in: the house is haunted. A poltergeist was at work in the kitchen. Dan's wife, Christine, returned home the next day, and when she arrived, Dan met her at the door and explained what he had seen the previous night in the kitchen. But to his shock and amazement, when they walked in, everything was spotless, clean and neat, and all the pots and pans had been put away. There was no sign of any poltergeist having been inside the house. He couldn't explain it, but he didn't want to go there, so he let it go. The seven boys and the three men never discussed what they saw— mainly because no one would ever believe them. Dan and Christine sold their house a year later and moved away. Rumors are that the house is clearly haunted, and it has been empty for several years now.

Another tale that people have shared is about the ghost dog. A family enjoyed dogs, and they would rescue a dog now and then. They even took in a few cats too. After fifteen years, there were two rescued animals left in their home: one was a cat, Katherine, and the other a Corgi dog, Arnold.

One afternoon, an extended family member brought over a female Rottweiler named Roxy because the family was moving and couldn't have pets in their new home. This Rottweiler settled in with the adopted family, and she enjoyed her walks with the children throughout the neighborhood and at the local park. She played with the family Corgi and enjoyed him very much. Arnold was thirteen when Roxy joined the family. What was unique about Arnold is that he was crippled—he didn't have use of his back legs anymore because of a disc problem in his back. After the veterinarian performed life-saving surgery on Arnold, he told the family they could use a Corgi Cart for Arnold to walk and become more mobile. Roxy was gentle with Arnold, and they would lay on their dog beds next to each other at bedtime. Their lives were blissful.

After a year, Katherine passed on in her sleep, and soon after, Roxy became ill, but during her last days, she was comfortable and not in pain. The veterinarian checked on her weekly, and it was decided she would need to be put to sleep very soon. It was a matter of days. She could no longer go on her walks because she was lethargic, and she required more sleep. The

family called the former owners so they could come to see her and say their goodbyes. The former owners had raised her since she was a puppy—for twelve years, they loved and cared for her.

As soon as the former owners walked in the door and approached Roxy, it was an injection of new life for her. She sat up and let out her sounds of excitement that dogs do, and she was trying to wag her tail. They sat on the floor to be right next to her, and she lay her head on her dad's lap and licked at her mom's fingers. Suddenly without warning, she went limp, and she passed away then and there. She knew her family had come to see her, and then she must have realized she could leave this earth now.

A week after Roxy had been buried, her adopted family was enjoying a movie on television when they heard the distinct bark of a dog. It sounded just like Roxy. Then Roxy's scent wafted through the room—it was a mixture of what some stinky dogs smell like when they have been running and the smell of that special dog food Roxy would eat. It was unmistakable. It was Roxy! The unpleasant aroma dissipated after a few minutes. She must have come to see Arnold because Arnold was not well. By this time, Arnold's fifteen years were beginning to wear him down. It was about two months after this incident that the family claims to have heard the sound of Roxy's feet thundering down the hallway, but nothing was there. This was followed by her distinct odor, which permeated the hallway. The next morning, Arnold passed away in his sleep. Had Roxy known that Arnold's time was near, and did she make her presence known because she wanted to communicate something to Arnold? Whatever it was, they were good friends in life, and perhaps they are good friends wherever they are now. Roxy has not been heard romping through the hallway again, nor has she made her presence known since Arnold left this earth.

Rancho Sespe, California

The Children and the Ghosts

Now is the time of night
That the graves, all gaping wide,
Every one lets forth his sprite
In the church-way paths to glide.
—*William Shakespeare,* A Midsummer Night's Dream

A tragic fire occurred in one of the homes at Rancho Sespe in the late 1950s. The four children had been left alone for the day because three were sick and the eldest child was old enough to care for them. Their mother had to go to work or she would lose her job—besides, they needed the money desperately. Their father had gone to Mexico to get another job, and he was expected back in the States within two weeks. He had called them and promised to be home soon with all of his earnings. It made sense to help mom and stay home from school to care for the two little ones and her seven-year-old sister. The neighbors noticed the smoke first and smelled the burning wood. They ran outside, saw the little house ablaze and called the fire department. In the meantime, the neighborhood women grabbed garden hoses and tried to douse the fire. When the fire engines arrived, they sprayed water on the fire and put it out within fifteen minutes. The firemen discovered the bodies of the four children in a back bedroom; all had perished. The neighborhood was stunned and devastated. Everyone is family in this small community, and they just couldn't believe what happened.

A favorite pastime for the workers at Rancho Sespe was to engage in boxing, as seen here. They also formed baseball teams and played against other ranch teams. *John Nichols Gallery.*

The coroner determined they had died from asphyxiation in the poisonous fumes. This was of little consolation to their mother, but at least she knew they did not burn. When her husband learned of the accident, he flew home immediately, and they held the wake and memorial services for the children. They were buried in the Bardsdale Cemetery, and the entire communities of Rancho Sespe and Fillmore did what they could to assist the devastated parents.

Time passed, and the parents moved away. The sad memories were too much for the mother and father, and they needed to heal and start their lives over. It is said that nothing is more devastating than the death of a child, and this family lost their four children to this fire. The burned house was demolished, and in time, grass and flowers grew over the empty lot. The neighborhood children would play there, and they always remembered the children who used to live there.

One day, three of girls decided to play jacks on the cement slab that used to be part of the back porch. They enjoyed one another's company and playing this game.

"Let's play with all twelve jacks today," announced Maria.

"Oh no, that's too hard for me—too many jacks. Let's play with eight," replied Louise, but Maria was relentless.

"No, it will do you good to practice, so let's play with twelve, and tomorrow, you can choose how many we are to play with, Louise." Maria was the diplomat of the group, and they listened to her because she was fair.

"All right, that's a good idea," added Susana.

So the girls began to play. The little red ball bounced too hard, and Maria missed it. It rolled away toward the grassy area. Maria jumped up to retrieve it, but it just kept on rolling. She followed it, and as she reached down to try to step on it so that it would stop, her foot slipped and she fell. She was all right, but she lost the ball. She was on her hands and knees running her fingers through the grass hoping to find it. As she did this, her fingers touched a hard object. She picked it up out of the grass—it was a girl's ring. It had a piece of turquoise in the center, and the setting looked like a dull silver. She forgot about the ball for a moment.

She ran back to show the other girls. When they saw what she had found, Susana cried out in surprise, "That used to belong to the girl who died in the fire. I know because my brother gave that ring to her." The girls were shocked that it had been found after all this time and was still in good condition.

Maria gave it to Susana, "Here, you take it," she said. "Give it to your brother. Tell him we were playing here, and I found it looking for the red ball."

That night, the girls didn't think too much about what had happened that afternoon. Maria had a stash of little red balls for jacks, so she just replaced the ball that had been lost in the grass. Maria was alone in her room and trying to fall asleep when she heard sounds outside. She couldn't explain what the noises were, so she found her flashlight and kept it close to her as she climbed out of bed. She pulled back the curtain and pressed her face against the glass. She saw a face peering back at her. It was the face of the oldest girl who had died in the fire. Maria recognized her instantly, but what was she doing there—she was dead. Maria rubbed her eyes and made sure she was awake and that she was seeing what she was seeing—the face of the dead girl. Her face was a grayish-white, and her eyes just stared back at Maria. The girl had long, dark hair, and it was matted and uncombed.

Maria realized she was looking at a dead girl. Little did she know that this girl had already gone to visit her other two friends, Susana and Louise.

By this time, Maria closed the curtain, grabbed her robe and ran out to find her parents. Maria's mom was already on the telephone talking to Susana's mother. "Yes, come over right away," she said. "We will go over everything. I'll tell Maria that you are coming. Yes, bring Louise and her

mother as well." With that last word, Maria's mom stepped into the kitchen, and she tried to calm down. She was so nervous, and as she poured water into the teapot, she dropped it. At this, she hastily picked it up, refilled it and held it steadily as she set it on top of the stove.

"Mom, what happened?" Maria asked. "Why are they coming over?"

Her mother replied, "Maria, did you find a ring today—well, yesterday?"

"Yes, Mom, I did," Maria said. "Susana said it belonged to the girl who died in the fire and that it was Susana's brother who had given the ring to her. Mom, I saw the dead girl's face in my window. I heard some strange sounds outside, and when I went to my window to peek outside, I saw her— her grayish-white face. She scared me and that was what I was going to tell you when I found you talking on the phone."

"Oh, *mija*, are you sure about what you saw?" Maria's mother asked. "Maybe you were dreaming. People don't come back from the dead."

"Mama, I know what I saw. I didn't understand it either, but I saw her."

After the others arrived, Maria led them into the kitchen-dining area, and they all sat around the table. Louise told about her experience when she saw the dead girl's face. Louise explained she was in the bathroom getting ready for bed. After she brushed her teeth, she looked into the mirror, and the girl's face showed up in the mirror too. Susana said she saw her in her room. She was awakened from a sound sleep when she looked up and saw the girl standing next to her bed. She screamed, and her mom ran into the room. Maria shared her experience, and now she was terrified. All the girls were frightened, and their moms were worried for their daughters.

Over the next few weeks, the families visited the church, and the priest came to bless their homes. They could not explain the sightings they had of this girl. The residents hoped that their small community had quieted down since the priest had come and offered his blessings, but that didn't happen. On the anniversary of the fire where the children perished of smoke inhalation, the face of the dead girl appeared at Maria's window. She was also seen in Susana's and Louise's windows. When Rancho Sespe was sold in 1979, the new owners proceeded to change the ranch operations, and all the housing camps were closed. These homes were demolished in the process. Perhaps the face of the dead girl no longer appears anywhere else, since these homes are gone, or she may be wandering elsewhere as she searches for her siblings and friends.

CRIES IN THE NIGHT

The murdered do haunt their murderers, I believe. I know that ghosts have wandered on earth. Be with me always—take any form—drive me mad! Only do not leave me in this abyss, where I cannot find you!
—Emily Brontë, Wuthering Heights

It was Halloween night, and Marissa, Janine and Sophia, dressed as witches, planned on collecting lots of candy. The girls were ten going on eleven years old. They were still "young girls," with all the sweet innocence little girls possess. They had strict instructions to stay together and not wander off or go into anyone's house.

They were having fun going to all the houses in their neighborhood. One house they were afraid to go to was one on Central Avenue, where an unsolved murder had taken place a month before, on September 9, 1989. A sweet older lady of about ninety years old had been murdered in her bed. The community was on edge as a result, but there weren't any suspects at that time. As the girls walked past the house, they heard someone crying. Each girl heard it, for it was very clear and distinct. It sounded like a lady crying, but they couldn't see anyone. There were small groups of children walking along with their parents, but nothing was out of the ordinary. The girls were becoming more nervous because it seemed as though they were the only ones hearing the cries.

"We have to get out of here. I don't want to think about it anymore," Marissa exclaimed. "Let's go to Sophia's house and be away from this place."

The girls ran to Sophia's house, which was only a block away. When they arrived, Sophia's mom was setting up the table with goodies and apple cider. The girls were frightened, and Sophia was so happy to see her mom and to be safe at home. Upon seeing the girls, Sophia's mom, Jenny, asked, "Girls, what happened? You are back so soon! That's fine, but I don't think you collected that much candy—your bags are practically empty. Did someone scare you out there when you were trick-or-treating?"

The girls didn't want to talk about it, and besides, nobody would believe them. How do you explain sounds that no one else hears but you and your friends? The girls decided to go for the comfort food—donuts, candy and apple cider. As they warmed themselves around the fireplace in the family room, they tried to act "normal" again.

Days and weeks passed, and the girls didn't hear any more cries at night. They occupied their time with homework, sports, church activities and, of course, their families. After they grew up, they discussed the cries they heard that Halloween night. Were the cries those of the lady who was murdered in her own house? Was she trying to tell the girls to be careful and to be wary when out on this scary night? Had the lady known her killer or killers when her life was snuffed out? She took that secret with her to her grave. The lady who was murdered was Florence Hackney, and she was described as a lovely, sweet lady. The Ventura County Sheriff's Department has three detectives working on thirty unsolved cold cases, including the Florence Hackney case. According to the Ventura County Cold Cases website, "Detectives do have a motive for this case, however, they are unable to release it to the public. The prime suspect is now deceased, but because there hasn't been enough evidence to prove the suspect did it, the case remains open."

This site was updated on June 26, 2013.

In Fillmore, everyone is family. It's a close-knit community, and the residents care for one another. It's a great small town. The neighboring communities of Bardsdale and Piru are similar. One family had just buried their father, the patriarch of the large clan, and the grown children took turns staying with their mother. She was older, and they wanted to be certain she was going to be all right without their father.

After a few months passed, life was getting back to normal, and one of the daughters would take over her little boy so Grandma could enjoy playing with him. He was already three and a well-behaved and smart child. On one visit, Grandma took out the blocks and some Lincoln logs for him to play with on the floor. After about ten minutes, he became distracted when

he saw the cordless telephone on the table. Luckily, Grandma kept another broken cordless phone for the children to play with that wasn't connected to the telephone line. Michael wanted to play with the telephone, so Grandma took down the children's cordless phone and plugged the electrical cord into the wall socket so it could still light up and make sounds when you pressed the buttons. She pretended to make a call, lifting the receiver to speak. Of course, it was a "dead" line, and there were no sounds. It was safe for Michael to enjoy.

Grandma settled down to do some sewing, and she could hear Michael talking to his mom on the phone. It was child's play, and he would say, "Yes, I want ice cream and a new toy." He also said, "Bring me crayons, please." She thought that was so cute. After a while, he wanted to play with the blocks. He put the phone away on the floor, took some blocks and laid them at Grandma's feet so he could play. He was building a tower when the telephone rang—but it wasn't the house phone that was ringing. It was that cordless phone that was not connected to a telephone line. Immediately, Michael's grandmother stood up and went to pick up the receiver. To her shock and surprise, when she said, "Hello," there was a crackling sound coming from the telephone and noise like when you have a bad connection. A voice could be heard, and it said, "Hello, are you…*crackle…crackle….*" Michael's grandmother didn't remain on the line to hear the rest. She threw the receiver down, unplugged the phone and took it outside to the recycle bin. She told Michael they had to throw it away because it was broken.

Shortly thereafter, her daughter arrived to pick up Michael and heard the story from her mother. Grandma knew it was a voice from beyond the grave because the telephone was not connected to a phone line.

PIRU, CALIFORNIA

TALES FROM RANCHO CAMULOS

There is nothing either good or bad but thinking makes it so.
—William Shakespeare

R ancho Camulos is one of America's premier historical landmarks. It
was built by Ygnacio del Valle in the 1850s when he convinced his new
wife, Ysabel, to leave Los Angeles. He promised to build a chapel, which he
did, and the various priests and Franciscan friars would come and say Mass
regularly. The Del Valle family had to sell Rancho Camulos when there were
numerous expenses that needed to be paid. Ysabel del Valle, who was very
ill toward the end of her life, passed away in 1905 while being cared for by
her daughter, Josefa.

Rancho Camulos was sold to August Rubel in 1924. It is currently owned
by the children of its second owners, August and Mary Rubel. It is also a
designated landmark. For many years, the local community has claimed
that Rancho Camulos is eerie and spooky at night. It is a scary place
after the sun goes down because it is isolated and there is so much history
associated with it. August Rubel moved his family from the Billiwhack
Dairy and Ranch in Santa Paula to Piru. The Rubels were aware of the
historical significance of Rancho Camulos, and they preserved it as an
example of early California architecture.

They added a schoolhouse, and a governess was hired to teach their
own children and the children of the bookkeeper, who also worked on the
property. Mary Rubel enjoyed exotic birds, and there was an aviary that

August Rubel is pictured here with a parrot on his shoulder at Rancho Camulos. His wife, Mary, housed many exotic birds in the aviary at Rancho Camulos. *Rancho Camulos Museum.*

housed the birds. One of their children passed away when he was a young toddler, and he is buried in the yard with a marked headstone.

On the night the St. Francis Dam collapsed, the rushing water surged down the San Francisquito Canyon toward the Santa Clara River, carrying away everything in its path. A row of eucalyptus trees along the Santa Clara River separated the Rancho Camulos property from the river. Fortunately, they served as a barrier, and the wall of water was unable to pass through the trees. This prevented any flooding of the main buildings and surrounding

The fountain on the south side of Rancho Camulos. *Robert Ybarra.*

area of Rancho Camulos. In Charles Outland's book, *Man-Made Disaster: The Story of St. Francis Dam,* he quotes Dr. H.C. Stinchfield, head of the Edison medical department:

> *I went up to the end of the line and found it was impossible to reach the former site of our camp. The men were all loud in their praise of a young man, whom I understand had recently acquired the Camulos Ranch. I have been told that as soon as they were brought to this ranch the owner furnished them with hot drinks, hot food, and all the clothes he had on the place… these men had on no clothes at all except what was given them by the owner of the Camulos Ranch.*

Dr. Stinchfield had written this in a letter, which is now part of the archives about the St. Francis Dam disaster.

Reginaldo del Valle, whose family owned Rancho Camulos until it was sold to August Rubel in 1924, was the president of the Los Angeles Department of Water and Power Commission at the time of the St. Francis Dam collapse.

In my book *Legendary Locals of Fillmore*, Lucy Alcozar Rangel shared how her father, Moises Alcocer, was one of those rescuers after the collapse of the St. Francis Dam on March 13, 1928. He shared, "The residents of the Santa Clara River had no warning and the police drove with their sirens trying to desperately warn the people of the impending danger." After the flood, he and a group of men went searching for survivors and victims, and they found many bodies buried in the mud with hands sticking out. There were dead animals and livestock tangled in the tree branches. Bodies of some of their relatives were found a few days later. The house and surrounding buildings at Camulos Ranch escaped the floodwaters as a bank of trees caught the debris and channeled the water away. The only damage was the loss of the lower orchards near the Santa Clara River.

At night, Rancho Camulos is eerie, and all sounds are magnified. The specter of a woman dressed in black has been seen walking through the garden and the courtyard. Others have heard sounds of people singing and the strumming of a guitar in the gardens. In the 1880s, the rancho was famous for its hospitality. The owners fed and housed weary travelers and

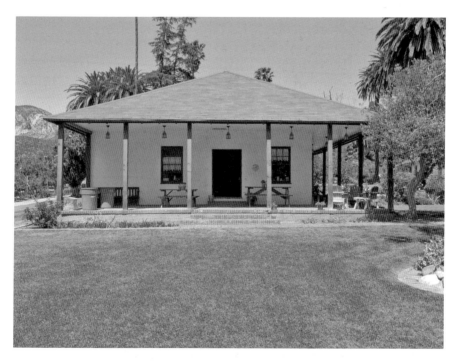

The schoolhouse August Rubel had built for his children when he purchased the ranch. *Robert Ybarra.*

hosted numerous visitors as they traveled from Los Angeles to the Mission at San Buenaventura. Reginaldo del Valle, one of the sons, was elected a California state senator, and he brought Charles Lummis to Rancho Camulos to recuperate from an illness. It was there that Charles fell in love with Susanita del Valle, who was sixteen at the time. Charles made wax recordings of the Del Valle sisters singing and playing the guitar. These are available at the Braun Research Center in Los Angeles, California. Charles also photographed the Del Valle family, and he created a photo album with the collection of eighty-three photographs he took. He gave the album to Susanita del Valle.

Charles Lummis and Reginaldo del Valle organized and formed the Landmarks Club, which was created with the intention of preserving the California missions—mainly San Buenaventura, Mission Santa Barbara and the San Fernando Mission. Others joined this group and were instrumental in convincing the Franciscans to restore and preserve the missions.

Perhaps it is Charles and Susanita who stroll the grounds at Rancho Camulos after midnight, under the watchful eye of Ysabel del Valle and the others who lived on the ranch at the turn of the century.

Hauntings at the Piru Cemetery and the Rancho Camulos Cemetery

They say that shadows of deceased ghosts
Do haunt the houses and the graves about,
Of such Whose life's lamp went untimely out.
Delighting still in their forsaken hosts.
—Joshua Sylvester

After the St. Francis Dam disaster, nineteen people were buried at the Piru Cemetery. They died tragically, no doubt, and what is etched in history is the image of Joe Gottardi searching for his family in the mud and debris in the Piru-Newhall area. Friends also helped search for his family. Joe Gottardi and one of his daughters survived, but the remainder of his family perished. Five of six family members were located, and those family members are buried at the Piru Cemetery. Joe's wife, Frances, was found in Santa Paula; Reno and Joe Jr. were located in Oxnard; Richard was found in Fillmore; and Pauline was located in Ventura. Lenore, who was four years old at the time, was never found. Many of the workers at the Kemp Edison Camp also perished in this disaster, and local residents of Piru have reported hearing men's voices, sounds of machinery and even some laughter emanating from the area of the Edison Camp where the men were working and staying in tents in 1928. The area is known as Blue Cut along Highway 126.

The first residents of Rancho Camulos were buried at the Rancho Camulos Cemetery, which is about a half mile to the right from the Rancho Camulos Museum buildings and across the street on the north

side of Highway 126. A white picket fence surrounds this cemetery, now abandoned. The earliest burial was in January 1863, and the most recent was January 1, 1985. There were eighty-six people buried there, until Ygnacio del Valle's body was moved, which left eighty-five bodies interred there. Ygnacio del Valle was buried there until Mrs. Ysabel del Valle had his body and coffin removed. She ordered it to be taken to her in Los Angeles, where she was living with her daughter, Josefa. Ysabel del Valle was in ill health, and she had the coffin next to her bed until she passed away. Upon her death, she asked that she be placed in the same coffin, and her wish was granted.

Today, after the sun goes down, one can hear the voices of children laughing and running in the cemetery. There are more sinister sightings reported here as well. Shadow figures have been seen darting behind the tombstones and hiding behind trees. Day of the Dead—Dia de los Muertos—is celebrated on November 1 and 2 throughout Central Mexico, Latin America and now Northern Mexico and the southwestern United States. It is considered America's newest holiday. The *ofrendas*, or altars, are set up in homes, and families celebrate the lives of their loved ones by remembering them. On the ofrendas, they place the favorite things their departed relatives enjoyed the most. On November 2, families go to the

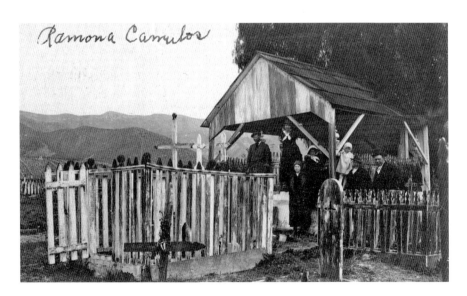

Herman Keene took his family to see Rancho Camulos, and they are at the site of the Del Valle family plot of tombstones and markers. Herman Keene was a colorful figure himself who had a reputation as a great hunter and outdoorsman. *John Nichols Gallery.*

The list of names of those buried at Piru Cemetery when Rancho Camulos was established. Ygnacio del Valle, the owner of Rancho Camulos, is listed here. *Robert Ybarra, from Rancho Camulos Museum.*

cemetery to honor their dead. They clean the tombstones and take food and sit around the grave, reminiscing about that person's life. They place marigolds on the adults' graves and white orchids on the graves of the children. They make sugar skulls and sweet bread, for it is customary. It is a ritual tradition the Aztecs also celebrated in Mexico.

The belief is that the gates of heaven are opened at midnight on October 31, and the spirits of the deceased children are reunited with their families for twenty-four hours. In the United States, this is known as All Saints' Day. On November 2, the spirits of the adults enjoy the festivities with their families as it is believed they, too, come down for twenty-four hours. This day in the Catholic calendar is known as All Souls' Day.

Today, the Mexican tradition of celebrating Dia de los Muertos (Day of the Dead) has taken hold in San Francisco, Los Angeles, Santa Barbara, Ventura and San Diego, as well as in Arizona, New Mexico and Texas, just to name a few places in the United States. Sugar skulls represent the souls, and the name of a loved one is written on the forehead. Sugar skull candy and items to make an ofrenda are now for sale on the Internet.

Visitors from the Past
and the Lady of the Lake

I love crime, I love mysteries, and I love ghosts.
—Stephen King

Behind every man now alive stand 30 ghosts, for that is the ratio by which the
dead outnumber the living.
—Arthur C. Clarke, 2001: A Space Odyssey

Lake Piru has been the scene of accidental drownings and various boat accidents that ended in tragedy. Despite these tragedies, people still enjoy fishing, boating and water-skiing at the Lake Piru Recreation Area. Legend states that the Lady of the Lake makes her way out of the water when tragedy is going to strike.

Some residents claim to have seen the Lady of the Lake as she emerges from Lake Piru at night. She has been known to swim underwater, and she will climb aboard boats and sit among the passengers. This is what happened one evening when a family of eight went out on the lake in their large boat. They were circling Lake Piru and enjoying the luscious scenery when one of the young girls screamed. On the bench where she was sitting, the empty spot next to her was dripping wet. She explained that she was sitting quietly looking out at the water when she felt something cold touch her right arm, and when she turned to see what it was, there was a lady sitting next to her. This lady was dressed in something white, and she was dripping wet. The young girl was frozen with fear as she tried to stand up, but she was

A view of Piru Lake, which is part of Piru Lake Recreation Area in Piru, California. *Robert Ybarra.*

This is Piru Dam as it looks today. It was built right over the previous location of Temescal School. Many people who worked at Rancho Camulos had attended Temescal School. *Robert Ybarra.*

suddenly paralyzed and unable to move. She did scream, however, and her mother heard the screams and then saw the ghastly apparition of the woman hovering over her daughter. The others on the boat rushed over to help the child, and the ghost woman stood up and jumped off the boat into the water. This time she was gone, and she didn't return for the rest of the night.

"We saw our ghost today, the apparition of the Lady of the Lake, and she came on board and left. Hopefully she will leave us alone now." These are the words the young girl's father wrote in his log. Similar entries were recorded on the preceding pages to his log, so this was not the first time he had witnessed the presence of the Lady of the Lake.

The family has since returned to the lake and gone boating and fishing. They try not to think about what they saw that night, but if the Lady of the Lake does come again, they will take her picture.

THE ROUND ROCK HOTEL
AND THE PIRU/NEWHALL MANSION

The house ghost is usually a harmless and well-meaning creature. It is put up
with as long as possible. It brings good luck to those who live with it.
—William Butler Yeats, The Celtic Twilight

The Round Rock Hotel was known as the Piru Hotel, Mountain View
Hotel and Heritage Valley Inn. It was originally a house built for David
C. Cook and his family in 1888, and they lived there until his permanent
home was completed. He had the Piru Mansion built for his family in the
Queen Anne style in 1890. D.W. Griffith and Mary Pickford stayed at the
Mountain View Hotel in 1910 while filming *Ramona* at Rancho Camulos.

The Piru Hotel was the only hotel between Santa Paula and Castaic
Junction. Harry Lechler's parents purchased the hotel in 1911, and they
changed the name from Mountain View Hotel to the Round Rock Hotel
due to the large round boulder in the front. Harry Lechler was born at
the Round Rock Hotel in 1912. Later, Harry and his wife organized the
Lechler Museum, with relics and historical objects on display. The Round
Rock Hotel was a rest home for the elderly from the 1950s to 1989. The
community of Piru is historical, and there are legends that surround this
community, beginning with the cave paintings left by the Tataviam people.

The Piru Indians are known as the Tataviam, and they left their imprint
painted on rocky surfaces and in secret caves throughout the mountains.
Some of their drawings depict humans as lizards, designs of hourglasses and
circles. They made baskets, and they were Christianized by the San Fernando

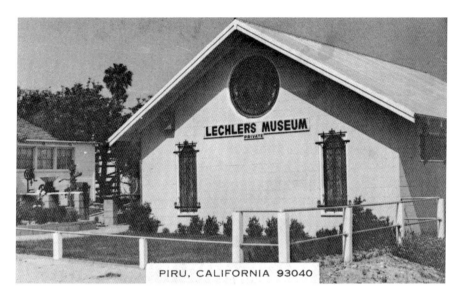

The Lechler Museum was a favorite place for visitors when they wanted to see historical objects from Piru and the surrounding communities. Mr. and Mrs. Lechler ran the museum until they closed it. *John Nichols Gallery.*

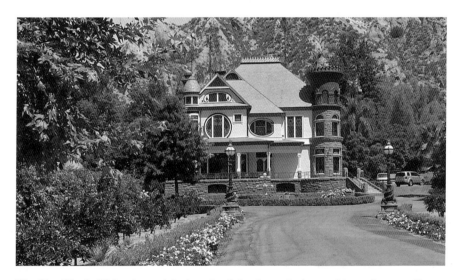

The Piru/Newhall Mansion as it looks today. It has been the haunted house in many films and television episodes. Today, it is a wedding venue. *Robert Ybarra.*

Mission. Many worked on large ranches, such as Rancho Camulos. Juan Jose Fustero called himself the last full-blooded Piru Indian, and he died in 1921. Gold was discovered in San Feliciano Canyon off Piru Creek in 1841. Adventurers and hikers claim the area is filled with spirits of the various Native Americans who inhabited the land, mainly the Tataviam people.

Residents claim that the Round Rock is haunted, as many have encountered strange happenings in the building. A woman has been seen looking out the upstairs window on more than one occasion.

The mansion in Piru has a very long history with the movie industry because it has been featured in numerous films and television shows. The mansion provides a historic site like no other, and it guarantees privacy without the public's peering eyes. Production companies have filmed episodes of the *X-Files*, *Charmed*, *Murder She Wrote* and numerous others. In the series *Charmed*, the mansion was a haunted house.

The legend is that the basement is the source of discomfort for those who resided at the mansion and for guests. It is designated as Ventura County Historical Landmark No. 4.

Hugh Warring purchased the mansion in 1912, and he installed three bathrooms with indoor plumbing. There is a story that some family members are reluctant to share that involves locking some of the relatives in the basement. Those who were locked in were terrified. After the Warrings sold the mansion to the Newhalls, Mrs. Ruth Newhall would invite the Warring family for frequent barbecues and swimming. The mansion was almost destroyed by a fire when it was undergoing repairs and a repainting project. With the help of the community and photographs taken by Philip Hardison, which he had taken for a master's thesis project, the mansion was completely restored. Today, it stands majestically against the foothills of Piru, overlooking the valley. If only those walls could talk, what tales would be told…

BIBLIOGRAPHY

Diaz del Castillo, Bernal, Janet Burke and Ted Humphrey, trans. *The True History of the Conquest of New Spain.* Indianapolis, IN: Hackett, 2012.

Nichols, John. *Essay Man: Selected Essays and Writings.* Santa Paula, CA: John Nichols Gallery, 2015.

———. *Images of America: St. Francis Dam Disaster.* Charleston, SC: Arcadia Publishing, 2002.

Outland, Charles F. *Man-Made Disaster: The Story of St. Francis Dam.* Ventura, CA: Ventura County Museum of History and Art, 2002.

Wilkman, Jon, *Floodpath: The Deadliest Man-Made Disaster of 20^{th} Century America and the Making of Modern Los Angeles.* New York: Bloomsbury Press, 2016.

Ybarra, Evie. *Legendary Locals of Fillmore.* Charleston, SC: Arcadia Publishing, 2015.

Pamphlets and Articles

Morgenstern, Joe. "The Death-Wish Kids." *Vanity Fair,* 1984.

Stansell, Ann C. "Memorialization and Memory of Southern California's St. Francis Dam Disaster of 1928." Master of Arts thesis, California State University–Northridge, 2014.

Ventura County Coroner. Transcripts of Testimony and Verdicts in Inquests over Victims of St. Francis Dam Disaster.

Reports

Joint Committee on Personal Property Damage, St. Francis Reservoir Flood. Report Submitted January 31, 1929 (final report in Ventura County Library).

Interviews

Georgia Haase Beck
Missy Pennington Cervantez
Bob Cox
Tom Hardison
Craig Held
Kris and Mike Hyatt
Barbara Leija
Eric Leija
Jeremy Leija
Ernie and Becky Morales
John Nichols
Pam Henderson Preciado
Tom Wilson
Robert Ybarra

INDEX

About the Author

E vie Ybarra has been collecting and writing stories since she was a child. As an educator who has taught elementary, middle school and high school students, she has planted the seeds in her students for them to become young authors. She and her students were awarded a California State Energy Award, and they competed on the national stage for the British Petroleum National Energy Awards. The community assisted in helping to raise funds to fly eight students, Evie and another teacher to Washington, D.C., for the competition. In collaboration with the *Los Angeles Times* in 1996, her class received several grants so the students could learn photography, and the culminating project was an art exhibition of the student photographs. Evie's love of history motivated her to create a family history project for her students in 2000, and her students compiled a series of interviews, photographs and primary source documents for inclusion in their family history books. Art was incorporated into the project via photography and drawings of family members. She shared her passion for the printed word by helping her students publish their own written stories and poetry.

Her first book, *Legendary Locals of Fillmore,* was published by Arcadia Publishing in 2015. That book included over 190 photographs of the local legends who created the communities of Fillmore-Bardsdale and Piru, California.

Her new book, *Ghosts of Ventura County's Heritage Valley*, shares many of the tales and folklore of the region, which includes Santa Paula, Fillmore, Rancho Sespe, Bardsdale and Piru. The impact the St. Francis Dam disaster had on the community (not to mention the Newhall, Santa Clarita Valley area) is evident in the local lore. She has dressed in costume and shared some of her favorite ghost stories at various events.

Evie hosted a radio show from 1989 to 2010, during which she interviewed numerous movers and shakers across the United States.

Besides traveling, photography is another of her passions. She has two children, Elizabeth and Robert Jr., and a wonderful son-in-law, Chris. Family is very important to Evie, and she remains connected to not only immediate family members but also to extended family members.